BRUSHWORK

Technique & Applications

With 52 Color Plates

BRUSHWORK

Technique & Applications
With 52 Color Plates

Stanley Thorogood

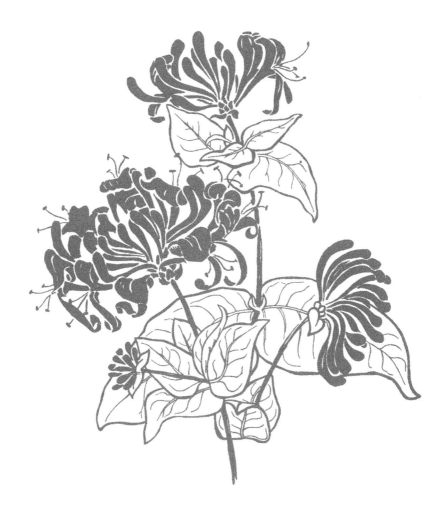

DOVER PUBLICATIONS, INC.
Mineola, New York

Bibliographical Note

This Dover edition, first published in 2015, is an unabridged republication of the work originally published by George Philip and Son, London, in 1907 under the title *The Manipulation of the Brush as Applied to Design: A Course of Brushwork for Elementary and Secondary Schools, 4th edition, revised and enlarged.*

Library of Congress Cataloging-in-Publication Data

Thorogood, Stanley, 1873–1953.
 [Manipulation of the brush as applied to design]
 Brushwork technique and applications : with 52 color plates / Stanley Thorogood.
 pages cm.
 ISBN-13: 978-0-486-79732-8 (paperback)
 ISBN-10: 0-486-79732-5
 1. Brushwork. I. George Philip & Son. II. Title.
 ND1505.T48 2015
 751.4—dc23

 2014049005

Manufactured in the United States by RR Donnelley
79732502 2015
www.doverpublications.com

CONTENTS.

PLATES.

PREFACE.

THE educational value of the use of the brush as a means of expressing form, and training the hand and eye, is gradually being recognised by educational authorities throughout the country.

I have compiled a few notes and illustrations that may be a guide to Teachers introducing the subject in Elementary and Secondary Schools, and Art Classes. No attempt has been made to arrange the work in progressive stages, as the drawings are not intended to serve as mere exercises or illustrations of design for scholars, but rather as a text-book on the subject of *Brush Drawing* for Teachers, showing different methods of interpretation, together with Historic examples.

In many instances the drawings illustrated are mere impressions sketched spontaneously with the brush as one would with a pencil, and are purposely left in that state to show how, in some cases, the brush should be used to sketch out IDEAS only (see Plates XXXII. to XXXVII.). Accuracy of drawing and detail must be the chief aim when working out the finished drawing.

Such exercise with the brush will be found invaluable, in order to apply it to practical use in designing and sketching from Nature.

It is a most difficult task to arrange Brush Drawing exercises in progressive stages, and experience teaches one that it is almost unwise to make the attempt.

In the case of the more advanced patterns or naturalistic studies it is impracticable. In many instances it would be impossible to state which particular example would present the greatest difficulty to the student. The chief aim in the lower classes should be to master the manipulation of simple strokes and the drawing of leaves, vegetable forms, and simple common objects, in silhouette.

A few photographs taken from the actual work of children attending Elementary Schools, ages varying from 5 to 13 years, have been added to illustrate the various stages of work from the lowest to the highest classes, both in Brush Drawing and Freehand and Application.

STANLEY THOROGOOD.

The
Manipulation of the Brush
as applied to Design.

Mr. Ruskin, in his Oxford lecture on " Line," says :

"The fact is that, while we have always learned, or tried to learn, to paint by drawing, the ancients learned to draw by painting. The brush was put into their hands when they were children, and they were forced to draw with that until, if they used the pen or crayon, they used them with the lightness of a brush or the decision of a graver."

The use of the brush, hand-in-hand with the pencil, is rapidly being recognised as an important medium for use in a child's early artistic training, and is advocated by the leading craftsmen and artists of the day.

It is only fair to the children in our public schools that those showing ability should have every opportunity of developing their powers, and that they should be taught drawing in such a manner that it may form a stepping-stone to higher work when passing on to local Schools of Art. The importance of teaching children to use the wrist and arm in drawing, to sit well back from their work, and to draw in a free style, cannot be over-estimated for any good Art work. Students doing advanced work in Schools of Art have to accustom themselves to work from an easel, and it will be seen how important it is that this principle should be insisted on in the most elementary stages of work, whether drawing with the brush or pencil.

The scheme for drawing in Elementary Schools, as shown in the Alternative Syllabus of the Science and Art

Department, is an excellent one, and it would be well if its principles were carried out in detail in every school.

It is necessary that cleanliness and good quality of line should be observed; but it is to be feared in the past that success has depended on the result of making the pencil do the work of a pen, instead of insisting, first and foremost, on good proportion and consideration of masses. From the very first, children should be taught to see the value of this; and for this purpose the introduction of brush and colour work is an excellent one. The early application of drawing to pattern-making, the tinting in of masses by means of coloured chalks and water colour, together with the use of the brush, as practised in a number of our large public schools, is a step in the right direction, for this work should go hand-in-hand with drawing. One can fully realize how such a subject as brushwork must be looked upon by teachers and others who have only regarded it in a superficial way; but those with a knowledge of drawing, if they study the effect of the brush, will soon see how by practice they can become somewhat dexterous in the handling, and will, at the same time, learn what results can be produced by the brush that the pencil could not give.

By using the brush, greater freedom of hand is acquired, while it is capable of developing powers of drawing beyond any other means. It forms a direct means of expressing mass and space, as well as line: it consequently assists the student to more rapidly appreciate the value of quantities, by directing his attention to spacing and to the solidity of the forms used. It is invaluable for training scholars to use the wrist and arm in drawing; in fact, it is in this teaching of handling and manipulation that the value lies in its use. Good results are the outcome of practice. To wield a brush with freedom requires a great amount of exercise and care. It is such a flexible tool, that, by varying the pressure, forms without number can be made; and it will be found that by it shapes can often be suggested that no other tool could possibly give.

To study the manner in which the Ancients used the brush as a means of decoration, one must visit our Museums, and notice the many examples of Ceramic Art, Persian tiles,

etc. The ingenious arrangements of brush forms on Greek vases are purely the outcome of the play of the brush. The Japanese acquire their ingenuity and skill in drawing by being accustomed from their youth upwards to the use of the brush as a writing and drawing implement. One could go on enumerating the many advantages of its practical use, as it bears directly on so many artistic industries ; and in a district where the artistic craft of pottery manufacture is carried on, one learns to appreciate its value.

In our prevailing methods of Art Instruction the various subjects are taken together, such as modelling, light and shade, elementary design, etc. This is as it should be ; and to those who have had any artistic training, it is clearly manifest that the whole range of Art subjects are linked together. The study of one assists the other, and in many cases a knowledge of two or three is absolutely necessary in order to do any practical work. It is to be regretted that more attention has not been given to the use of the brush and colour work. I can speak from experience. I have found more than one student, with no little powers of draughtsmanship, quite ignorant of the handling of the brush (a tool he finds he most needs), and with no knowledge of colour mixing, so essential to the enrichment of any practical decorative work.

In studying any examples of brush play on vases, or what not, it will be seen that the charm lies in the free handling and artistic quality of the handwork. It is a mistake to think one can accurately imitate lithographic reproductions, machine-like in character; for, in so doing, the student is trying to copy something he will never succeed in representing. The drawings in this book are reproduced in such a manner as to show all the accidental effects. It will be found impossible, when using the brush with the freedom that is necessary, to be mechanically accurate as to the symmetry of patterns, because hand work is bound to assert itself and show its individuality.

Many books have been published for Kindergarten work in Infant Schools, and it is clear that the use of the brush, as applied to this class of work, cannot go far beyond the making of patterns by means of the shape of the brush, or by representing such types of Nature as most readily lend

themselves to this style of reproduction. In this sphere of work, the brush is most useful in directly giving a variety of interesting forms and representations of natural flowers and foliage, which form excellent examples as object lessons in training the child to observe. Experience teaches me that using the brush in Infant Schools in the manner known as blobbing (*i.e.*, placing the brush heavily on the paper until the ferrule touches), is harmful to direct work, and, when children have been taught such methods, it is difficult to teach them to draw directly.

Suggesting simple plant forms, vegetables, and well-known simple common objects, should form the chief feature of drawing with the brush in the Infant School.

The squared paper, sometimes used for brushwork, should only be used, in order to keep the various units, when repeated for practice, in a somewhat orderly manner; but this class of work should only be done for the purpose of getting the children into the handling of the brush. The less squared paper is used in the school the better, as it tends to the mechanical.

Brushwork lessons should be demonstration lessons, but the demonstration should not take place until after the child has had an opportunity of making an attempt by himself without any aid. As it is necessary to have the paper somewhat upright, in order that the pupils may see, it will be found rather difficult for the teacher to work with water colour, as it tends to run down ; but this can be overcome with care by having the colour a little thicker than the pupils', which is also an advantage, as it is more clearly visible from a distance. After a simple unit or leaf form has been demonstrated, it should be repeated again and again for practice, thus allowing the teacher to give individual attention. Scholars, after having lessons in the various movements, should be allowed to make forms of their own (keeping them orderly), as it is evident the variety of movements that can be obtained with the brush are innumerable, and those given in this book should not serve as mere copies, but form suggestions to go still further. The aim should be to train the inventive faculties.

During a brushwork lesson, senior scholars with a good knowledge of drawing should be allowed to sketch various units as suggested, such as leaves, flowers, etc., etc.; then rule out construction lines, based on the square lozenge shape, circle, ogee, etc.; then sketch out simple suggestive masses, to fill the spaces to form even all-over patterns; this forming an excellent lesson on the early application of drawing to design. Scholars doing this class of work would have had a very good groundwork on drawing with the pencil; and in using the brush would find it an excellent means of suggesting ideas with a freedom which, by using the pencil, would not so readily have been attained.

COLOURING.

Lessons on the use of colour mixing should be given during the tinting-in of the application of Freehand copies, as seen in the many excellent sets of copies on the early application of drawing to pattern-making, now being used in most of our big Elementary Schools. Brushwork is apt to be depreciated by some authorities on account of the time said to be taken in giving out materials. It is a pity that this should be considered a drawback, as by methodical arrangements, and keeping colour already mixed in large bottles, it can be served out in extra ink-wells for the purpose—a plan which I find works very well. It must be remembered that *for a brushwork lesson it is not so much the colour as the handling that should be the object.* Coloured inks are very useful for brushwork lessons, and work much easier than ordinary colour, at the same time being less expensive.

The illustrations in this book are printed in six of the different coloured inks obtainable for the purpose.

If coloured inks are used, great care must be taken in cleaning them after a lesson, and before using a different colour. Excellent effects can be obtained by using Chinese white on toned paper, thus giving light ornament upon a dark ground.

In some large schools, however, senior scholars can afford to buy a box of paints for their own use, which is an advantage, as it is essential they should learn to mix colours. Brushes should be kept very clean. A very good way to keep them is standing upright in a jar on the handle end, to ensure the points being kept straight.

COLOUR MIXING.

It is evident that there is no limit to the variety of hues obtainable by mixing colours, and any attempt to produce colour harmony by a dry formula is bound to fail. Some general principles can be laid down to serve as a guide and as starting-points on which to base experiments; but "colour" can only be learnt and appreciated by repeated practice, and by observing Nature and the many beautiful Works of Art in our Museums, such as pottery, glass, tiles, fabrics, etc. For this reason it would be an admirable plan if the elder lads in our Board Schools could be taught to see them, and occasionally visit the local Museum.

Primary Colours : Blue, Red, Yellow.
Secondary „ Obtained by mixing any two of the Primaries.
Blue and Yellow make Green.
„ „ Red „ Purple.
Yellow and Red „ Orange.

These six hues—viz., Red, Orange, Yellow, Green, Blue, and Purple—form the six principal colours.

Tertiaries. Combining any two of the Secondary hues a third order of Colours is produced.
Orange and Green give Citron.
„ „ Purple „ Russet.
Green „ „ „ Slate.

The Tertiary hues, however, are nothing more than Grey with an extra tinge of one or other of the six leading colours; and Professor Church, in his "Elementary Manual," gives them as Red, Grey or Russet, Orange, Grey or Buff, Yellow, Grey or Citrons, Green, Grey or Sage, Blue, Grey or Slate, Purple, Grey or Plum.

To these may be added *Neutral Grey* when the colours perfectly neutralize each other, the extra tinge being absent.

A few characteristics of the Colours may be of use.

Prussian Blue.	Strong, transparent Blue, with a tendency to Green. Works well. With Gamboge, gives Bright Greens.
Cobalt Blue.	A Light Blue; exceedingly useful; not very easy to work with. Gives beautiful Greys, with Light Red.
Gamboge.	Very clear transparent Yellow. Works well. With Sepia, gives a very sober Green.
Raw Sienna.	Transparent Yellow.
Venetian Red.	Inclines slightly to Orange. It works easily, and mixes well with other colours.
Crimson Lake.	Inclines to Purple. Works extremely well.
Sepia.	A strong Brown, sometimes cold. Works well for Monochrome work.
Burnt Sienna.	A beautiful Golden Brown, Transparent. Works very easily.
Vandyke Brown.	A fine deep Brown.
Chinese White.	A dead White. Will be chiefly used to give body to other colours.
MATERIALS.	The Materials necessary for Water Colour Work are Colours, Brushes, Palettes, Water Bottles, and a Pad of Blotting Paper. Good Brushes are indispensable, and should be of fair size. Siberian Hair Brushes, though inferior to Sable, are better than Camel Hair for laying on Colour. For ordinary class work, six Colours will be found ample, and of these, perhaps, Prussian Blue, Crimson Lake, Light Red or Venetian, Gamboge, Burnt Sienna, and Sepia will be found the most useful.
	Ordinary Ink Wells are useful for class work, when it is necessary to give out the Colours already mixed.

LAYING IN A WASH OF COLOUR.

The Colour should be well mixed, and stirred up every time a fresh brushful is taken.

It is advisable to damp the surface of the paper with clean water before starting to colour.

Work quickly, and with plenty of colour in the brush. Half the smudgy, patchy washes of colour are due to working with too dry a brush.

When once a wash of colour has been laid on, never touch it again until it is thoroughly dry. If it should be patchy, leave it so, as any retouching while wet can only make matters worse.

PRACTICE.

In the majority of movements the brush should be held lightly, so that it can be at times revolved between the fingers, in order to bring it to a point when finishing off a stroke. It is most essential that scholars working with the brush (as in the case of the pencil) should have slanting desks or boards, and sit well back from their work. It is to be feared that the majority of school desks are far from what they should be for drawing purposes, the only remedy being to use drawing boards, which can be tilted at any angle. To obtain direct brush strokes, the brush should be held somewhat at right angles to the paper, and the more horizontal the paper has to be placed, on account of the desks, the more vertical the brush must be held, as with holding the brush at too acute an angle with the paper, such forms as shown in Fig. 6b, Plate II., will be the result. This is important for direct brush strokes; but for rough sketching and suggesting, the brush can be held at will.

It is difficult to divide the course of work into separate standards, but it must be distinctly understood that advanced work cannot be accomplished without thoroughly practising simple forms, in order to get into the manipulation of the brush. In the lower standards the time should be spent in repeating the variety of simple movements, combining them as each form is mastered. It will be seen that a great variety of patterns can be produced by such combination, as illustrated.

Radiation is an important principle to be observed in all ornamental work, particularly so with brushwork. A very good way in a first lesson is to draw with pencil varieties of radiating lines, afterwards going over them with the brush.

Many patterns will, at first sight, appear to be somewhat complicated and difficult, but when analyzed will be found to be merely the repetition of simple units; and if taken step by step by the teacher, will be easily grasped by the student.

The importance of repetition in design should be clearly demonstrated to students, as the majority of patterns are the outcome of the repetition of some unit. Children should be taught to observe patterns as seen in many of the school class rooms, such as dado stencil borders, tile patterns, etc., etc., thus illustrating this principle.

Examples of Children's Work.

Freehand.

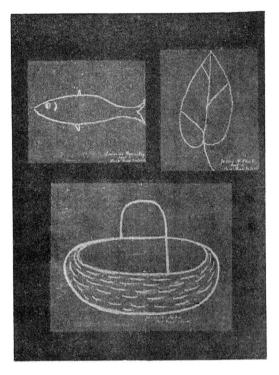

1.—Infants' Class, I. and II.

Freehand and Application.

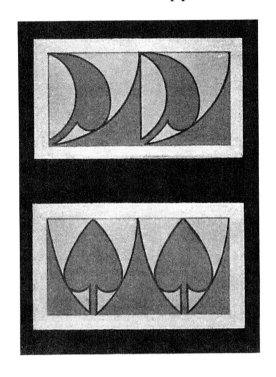

2.—Standard I.

Freehand and Application.

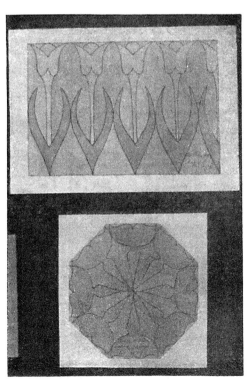

3.—Standard II.

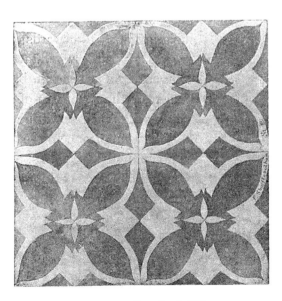

4.—Standard III.

Examples of Children's Work.

Freehand and Application.

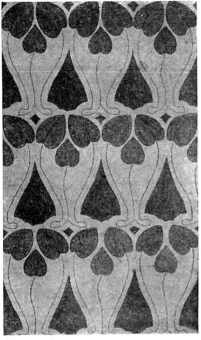

5.—Standard IV.

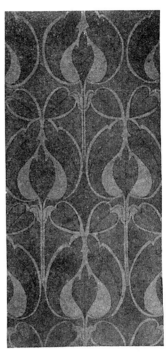

6.—Standard V.

Freehand and Application.

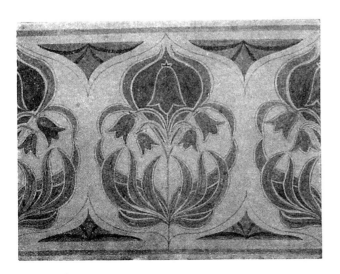

7.—Standard VI.

Lettering.

8.—Standard VII.

Examples of Children's Work.

Animals from the Flat.

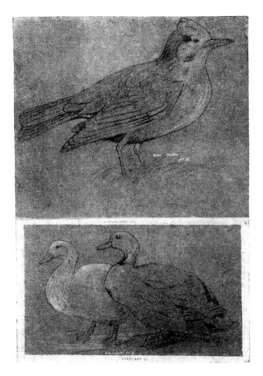

9.—Standard VII.

Nature Drawing from the Flat.

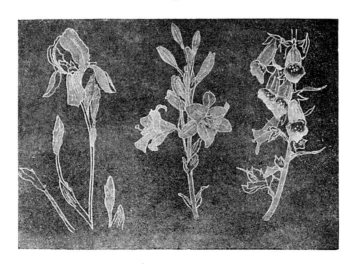

10.—Standard VII.

Examples of Children's Work.

Brushwork.

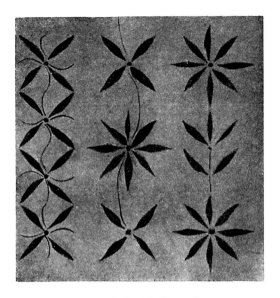

1 —Infants' Class, I.

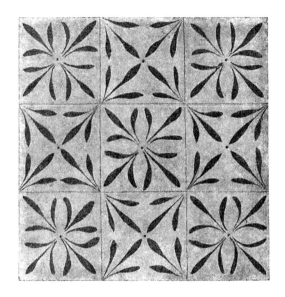

2.—Standard I.

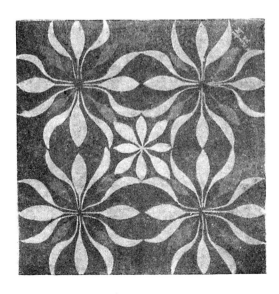

3 —Standard II.

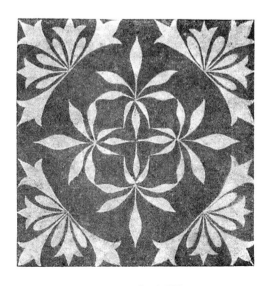

4.—Standard III.

Examples of Children's Work.

Brushwork.

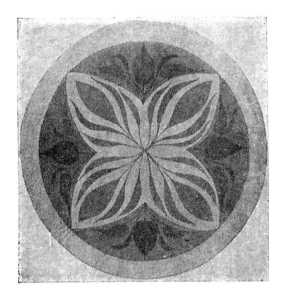

5.—Standard IV.

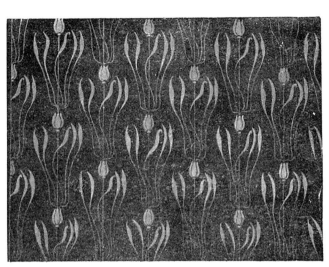

6.—Standard V.

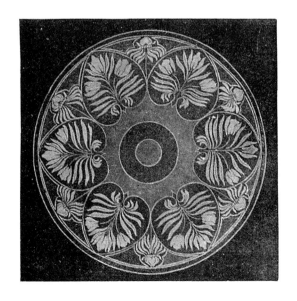

7.—Standard VI.

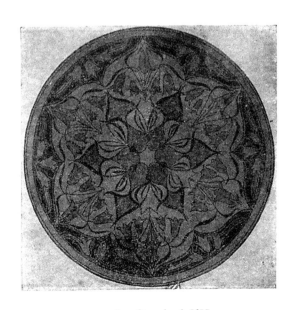

8.—Standard VII.

Plates.

Plate I.

Thoroughly practise these movements, as it is by the combination of these strokes that the most complicated patterns are made ; at the same time the manipulation required to obtain them is invaluable in training the movements of the wrist and arm.

Fig. 1. The first movement of the brush, by first pressing heavily, bringing it up sharply and lightly to a point.

Fig. 2. The opposite movement.

Fig. 3. First press heavy, bringing it round from left to right. Hold the brush somewhat at right angles to the paper, revolving it slightly between the fingers, in order to bring it to a fine point in finishing off.

Fig. 4. The opposite movement.

Fig. 5. Radiating from line to line, starting lightly, and finishing off lightly.

Fig. 6. Radiating into a line, starting by pressing somewhat heavily, finishing off lightly, revolving the brush a little between the fingers.

Fig. 7. Opposite movement.

Fig. 8. A double twist with the brush.

Fig. 9. Hold the brush vertical, press heavily, bringing it very sharply round to a thin line.

Fig. 10. Make a large dot with the brush, working it round and round ; finally bring it off sharply, as shown.

Plate II.

Scholars should be taught to draw bold forms in a free manner, endeavouring to make the most of the flexibility of the brush by varying the pressure, as shown in Figs. 1, 2, 3, 4, and 5.

Before getting into the lightness of touch, scholars will be found making such strokes as 6*b* and 7*b*, instead of 6*a* and 7*a*. Such will also be the result if the brush is not held at the proper angle as explained. In first attempts of Fig. 8*a*, if the scholar is not taught the principle of radiation, Fig. 8*b* will be the result.

Figs. 9, 10, and 11 show the formation of serrations on leaf forms, illustrating radiation. Fig. 11, they are drawn in mass. See **Plate IX.**

Figs. 12 and 13 illustrate two different treatments of the same unit.

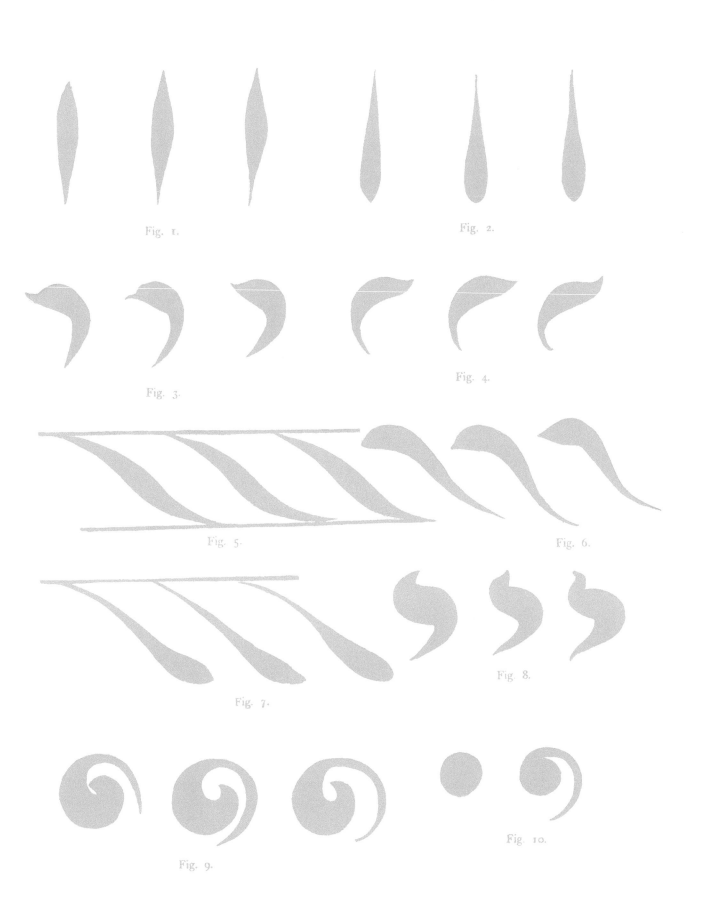

Fig. 1.

Fig. 2.

Fig. 3.

Fig. 4.

Fig. 5.

Fig. 6.

Fig. 7.

Fig. 8.

Fig. 9.

Fig. 10.

Plate I.

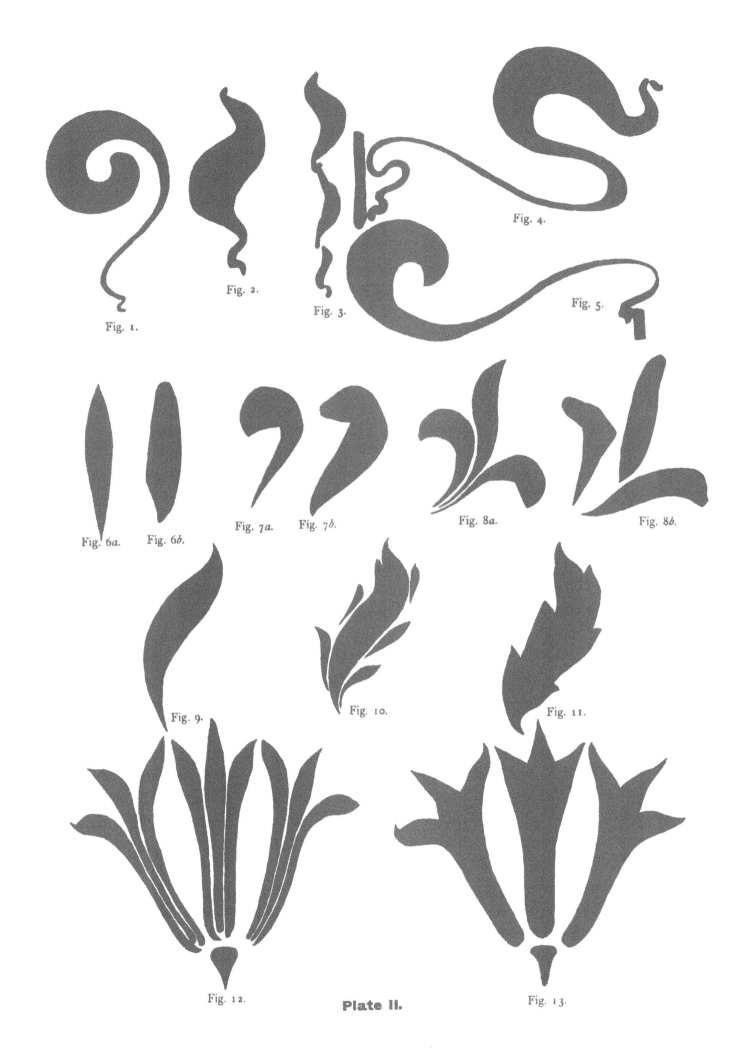

Fig. 1.

Fig. 2.

Fig. 3.

Fig. 4.

Fig. 5.

Fig. 6a.

Fig. 6b.

Fig. 7a.

Fig. 7b.

Fig. 8a.

Fig. 8b.

Fig. 9.

Fig. 10.

Fig. 11.

Fig. 12.

Fig. 13.

Plate II.

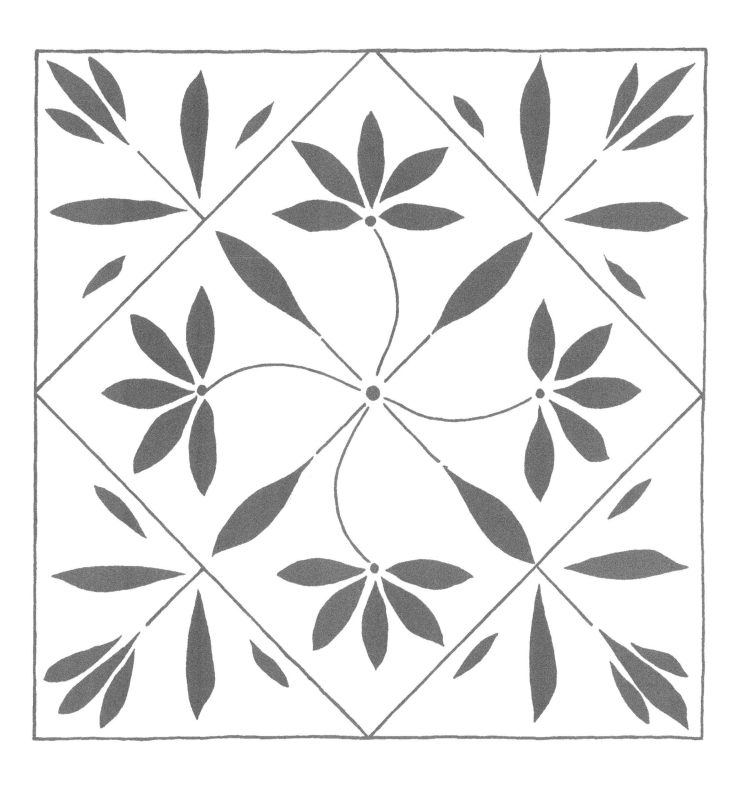

Plate III.—Showing the class of work to be carried out in Infant Schools. These forms should not be obtained by pressing heavily on the paper, but by a slight movement.

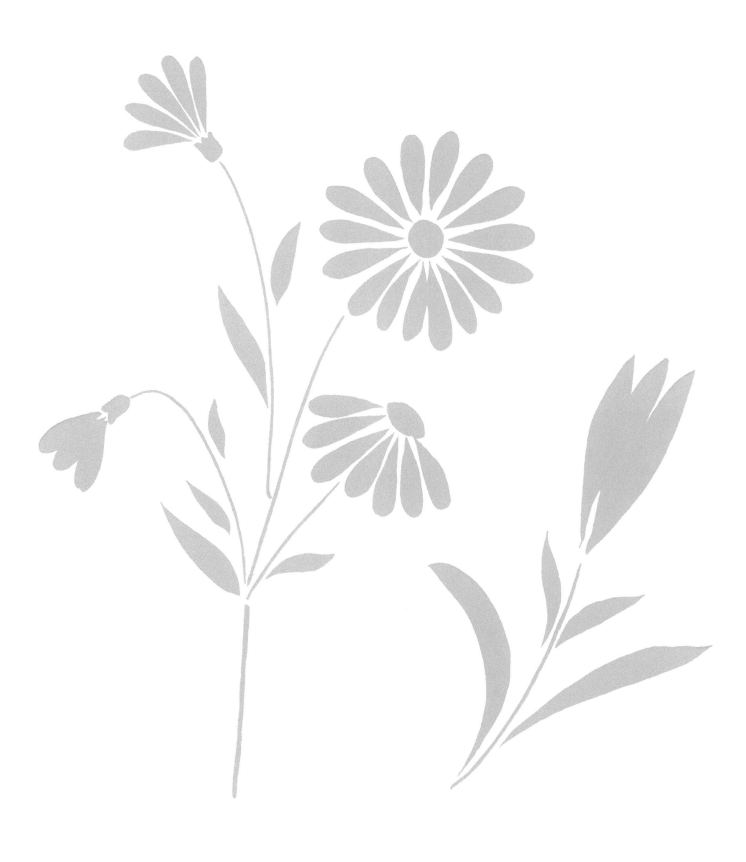

Plate IV.—Showing the class of work to be carried out in Infant Schools; viz. (suggesting rather than attempting to copy) naturalistic forms that lend themselves to brush treatment.

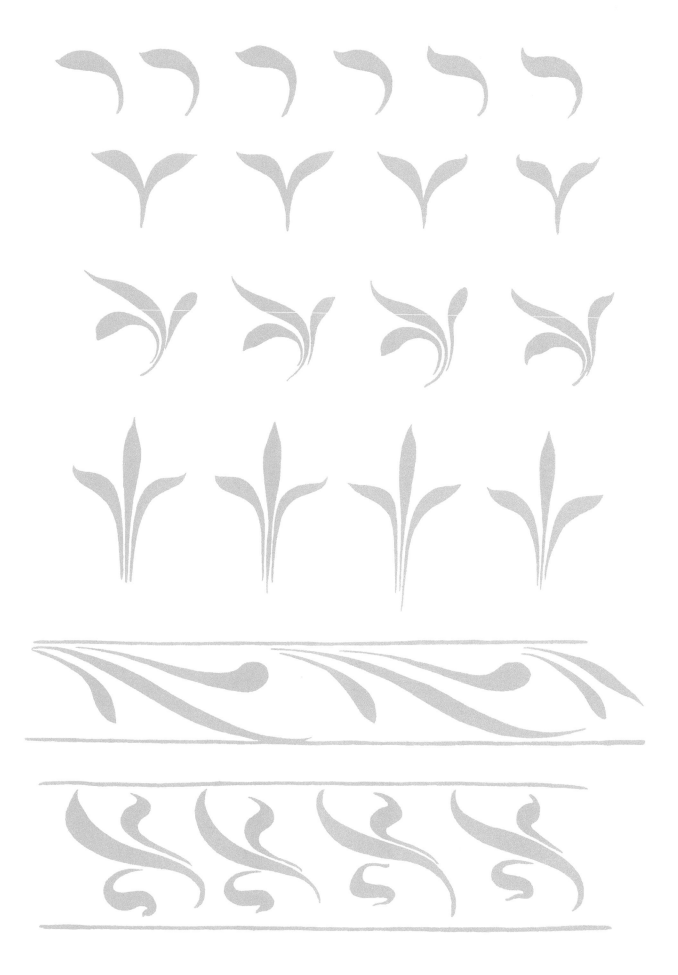

Plate V.—Illustrating the combination of the various strokes to form simple patterns. A number of lessons can be made up by the combination of these forms.

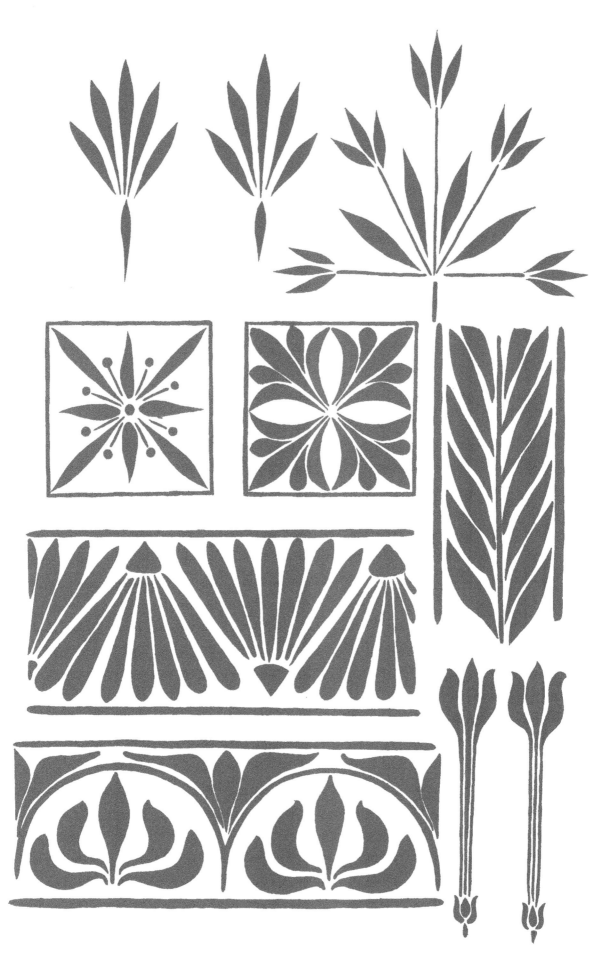

Plate VI.—Illustrating the combination of the various strokes to form simple patterns.
A number of lessons can be made up by the combination of these forms.

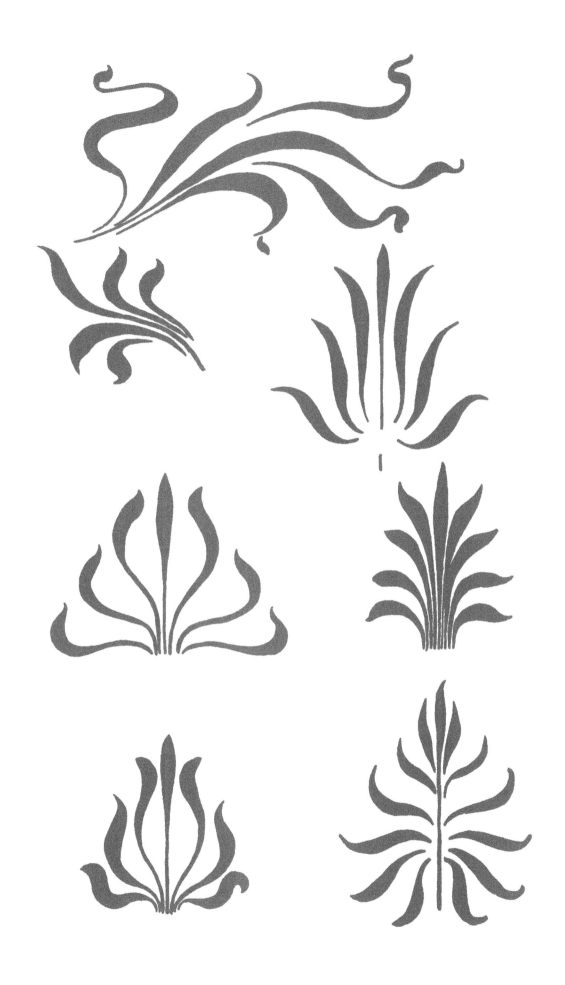

Plate VII.—Showing various radiating brush strokes, which should be continually practised.
See Plates XXXVIII. to XL.

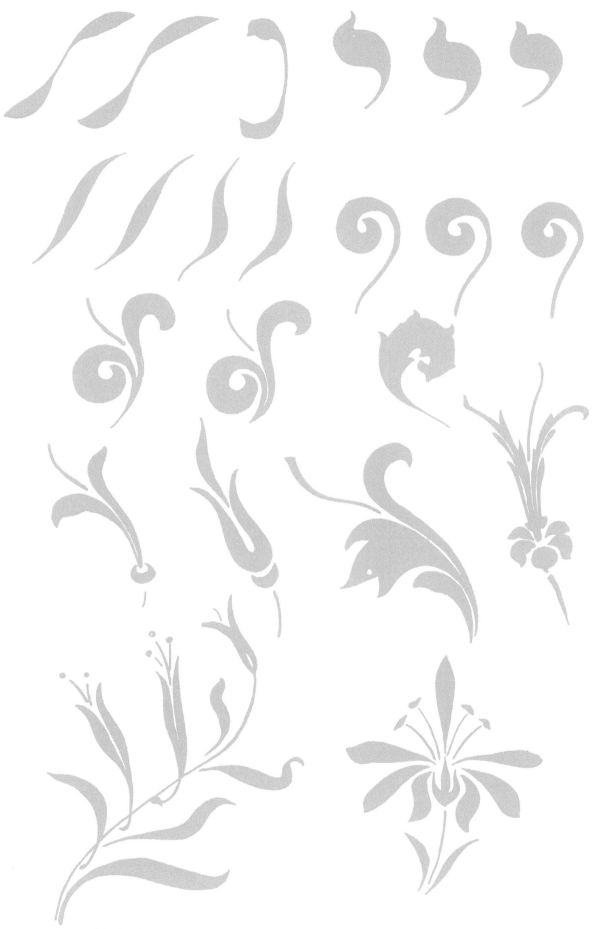

Plate VIII.—Showing various types of natural and conventional forms, drawn direct with the brush, forming good examples for practice in manipulation, which can also be repeated to form designs for filling various shapes and all-over patterns.

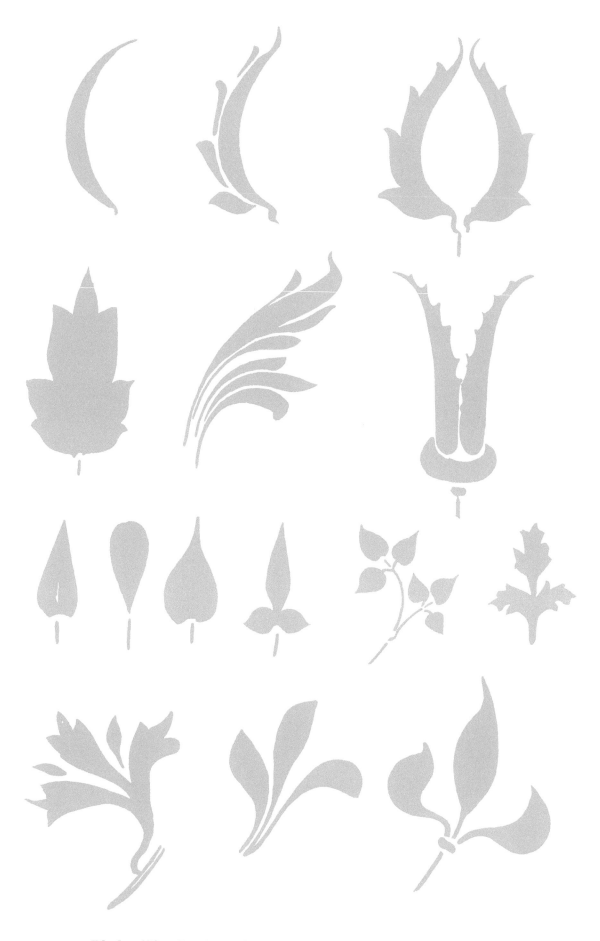

Plate IX.—Showing various types of natural and conventional forms, drawn direct with the brush, forming good examples for practice in manipulation, which can also be repeated to form designs for filling various shapes and all-over patterns.

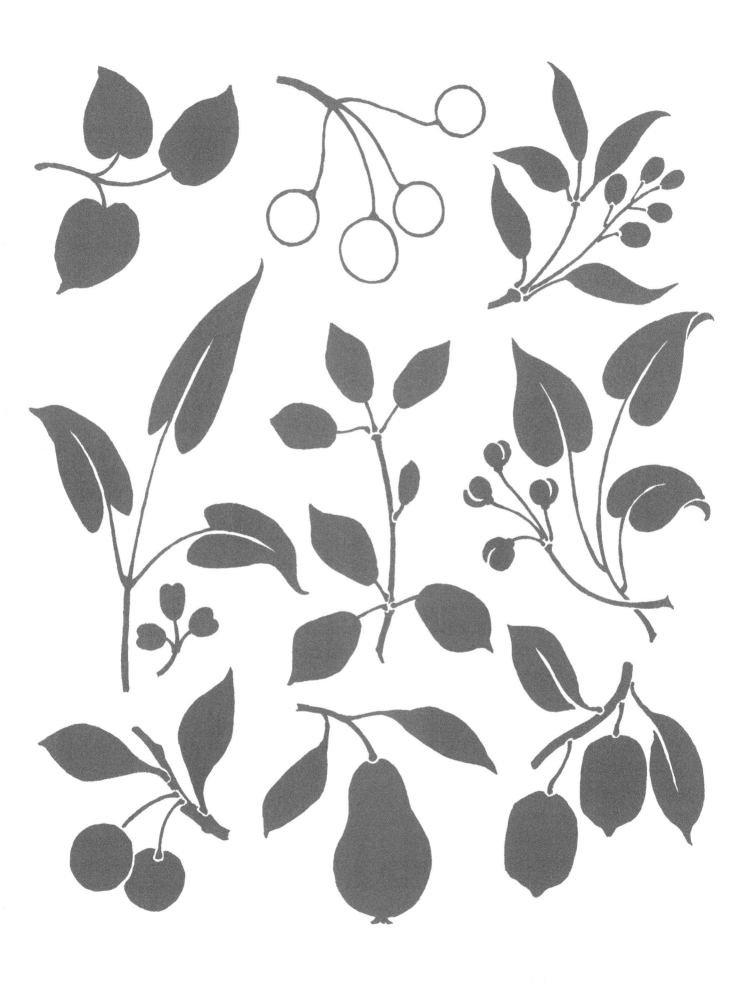

Plate X.—Showing various simple treatments of leaves and fruit.

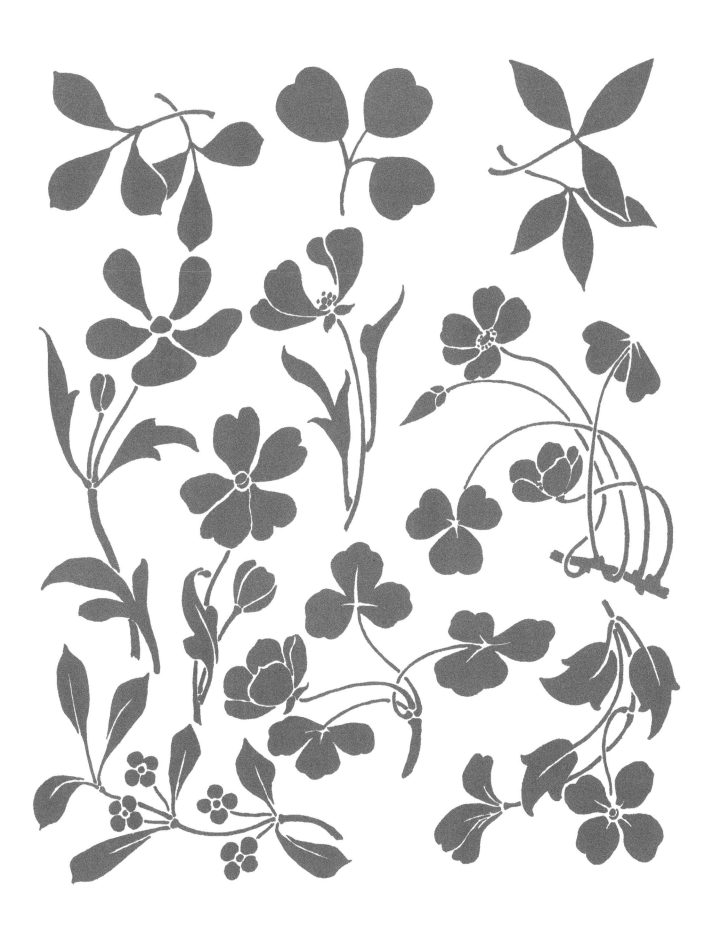

Plate XI.—Various treatments of leaves and flowers.

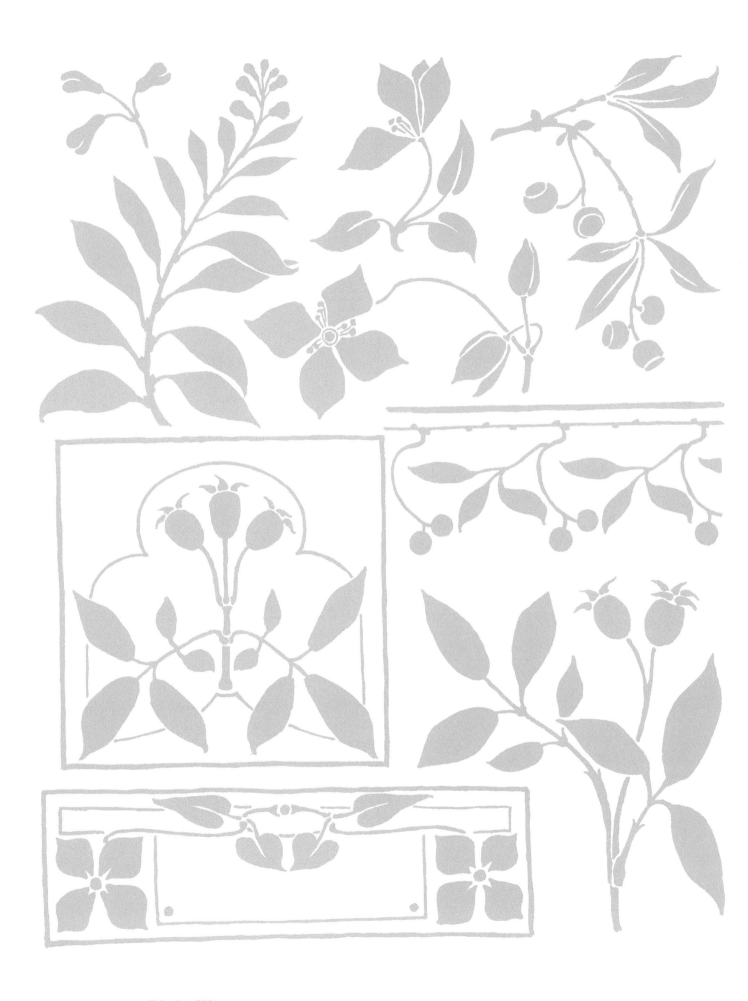

Plate XII.—Various treatments of leaves and berries, showing suggestions for design.

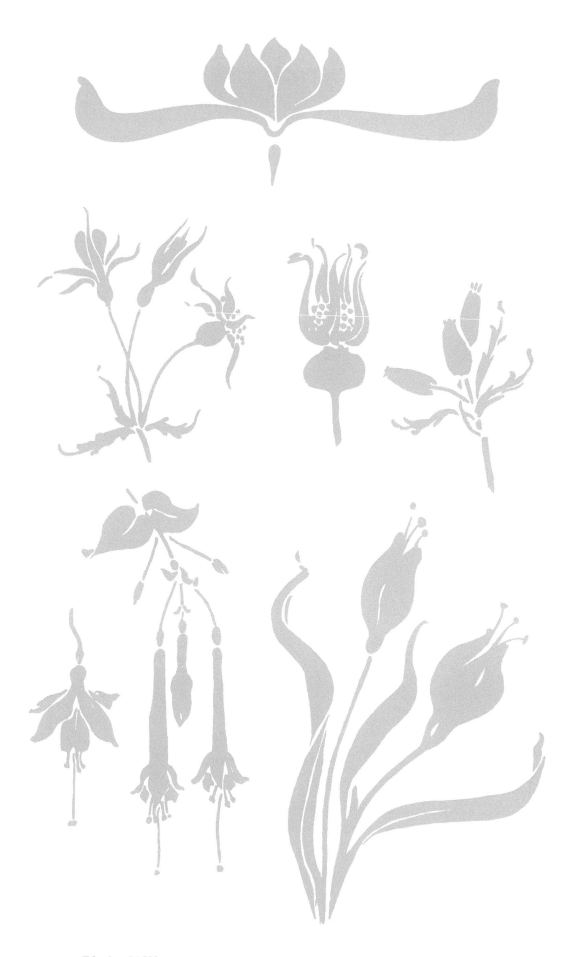

Plate XIII.—Showing various types of natural and conventional forms, drawn direct with the brush, forming good examples for practice in manipulation, which can also be repeated to form designs for filling various shapes and all-over patterns.

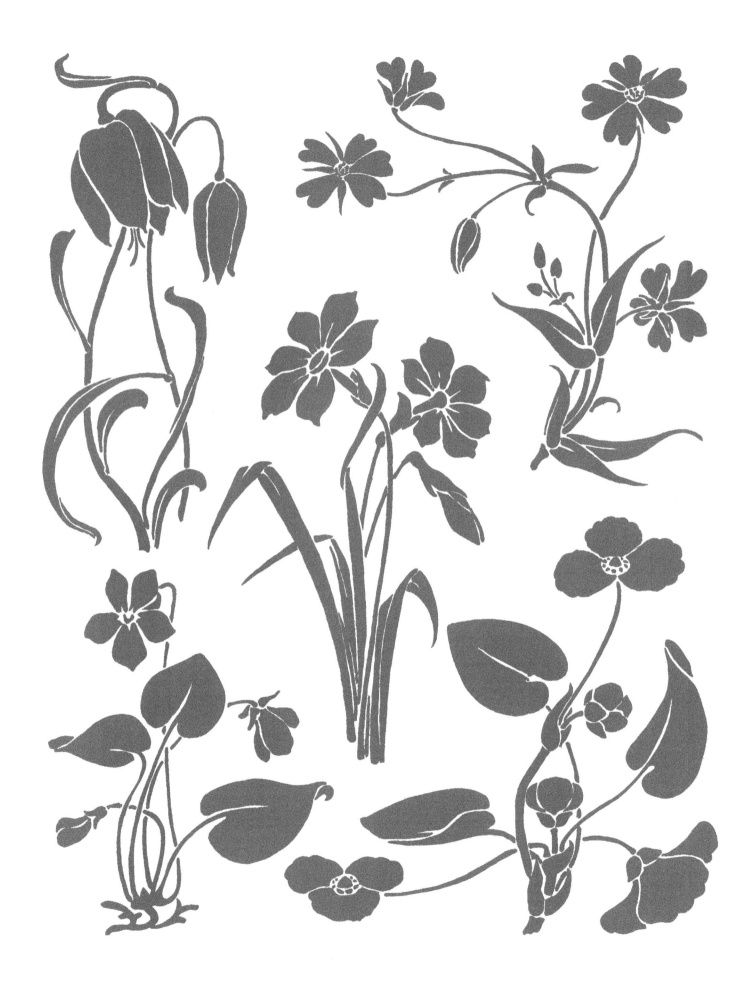

Plate XIV.—Silhouette plant studies.

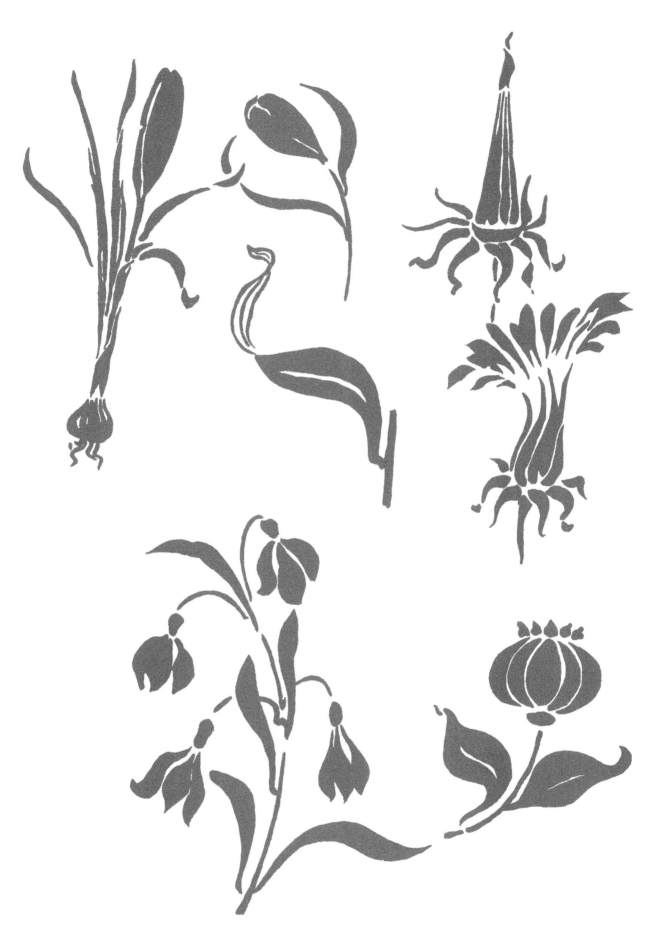

Plate XV.—Showing various types of natural and conventional forms, drawn direct with the brush, forming good examples for practice in manipulation, which can also be repeated to form designs for filling various shapes and all-over patterns.

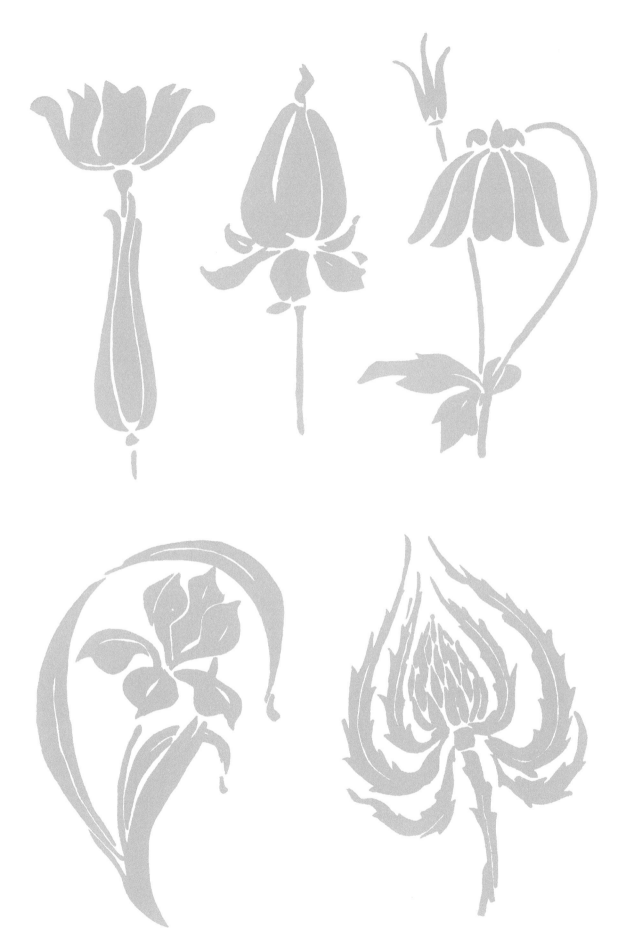

Plate XVI.—Showing various types of natural and conventional forms, drawn direct with the brush, forming good examples for practice in manipulation, which can also be repeated to form designs for filling various shapes and all-over patterns.

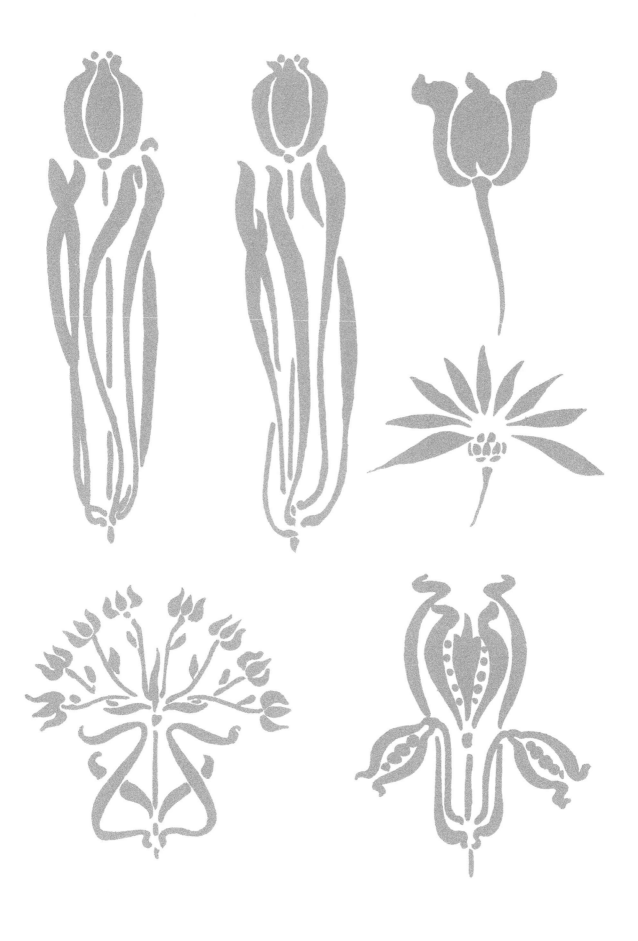

Plate XVII.—Showing various types of natural and conventional forms, drawn direct with the brush, forming good examples for practice in manipulation, which can also be repeated to form designs for filling various shapes and all-over patterns.

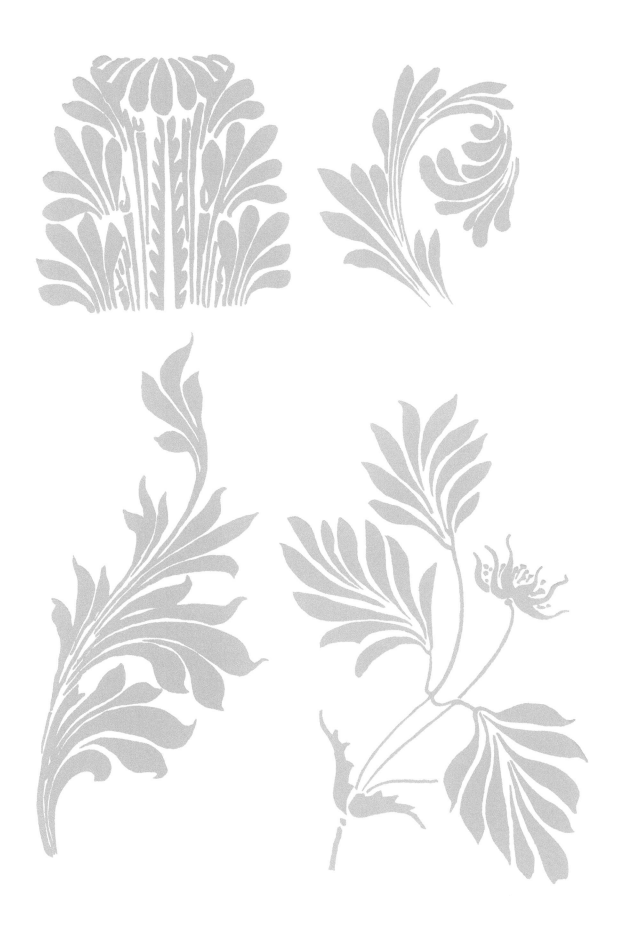

Plate XVIII.—Showing various types of natural and conventional forms, drawn direct with the brush, forming good examples for practice in manipulation, which can also be repeated to form designs for filling various shapes and all-over patterns.

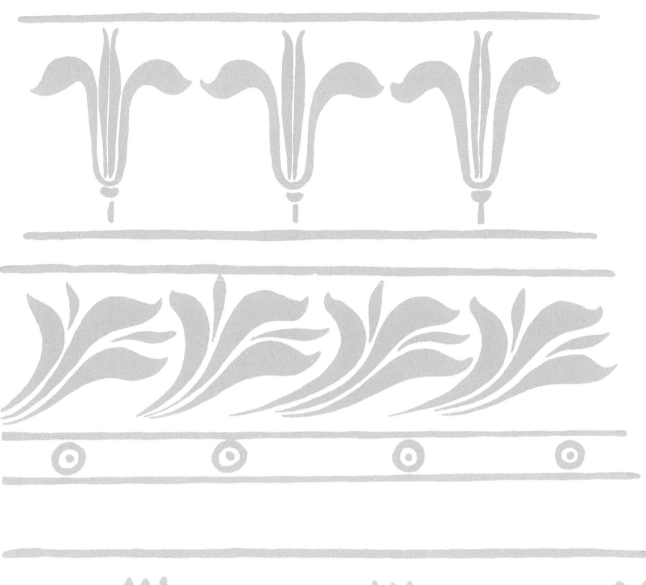

Plate XIX.—Series of designs drawn with the brush.

In the more difficult patterns, the position of important masses should be slightly indicated with pencil, after which the whole should be drawn direct with the brush, aiming rather at freedom than perfect symmetry.

Plate XX.—Series of designs drawn with the brush.

In the more difficult patterns, the position of important masses should be slightly indicated with pencil, after which the whole should be drawn direct with the brush, aiming rather at freedom than perfect symmetry.

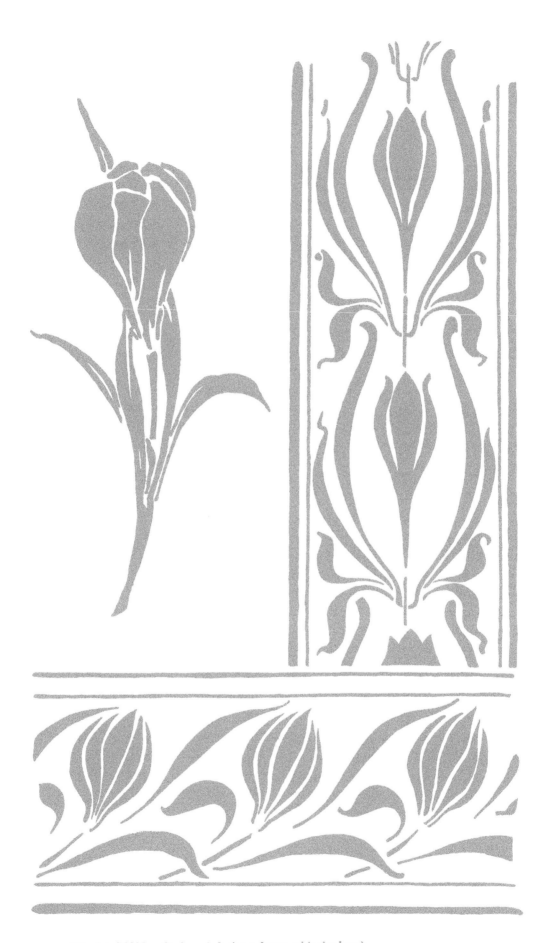

Plate XXI.—Series of designs drawn with the brush.

In the more difficult patterns, the position of important masses should be slightly indicated with pencil, after which the whole should be drawn direct with the brush, aiming rather at freedom than perfect symmetry.

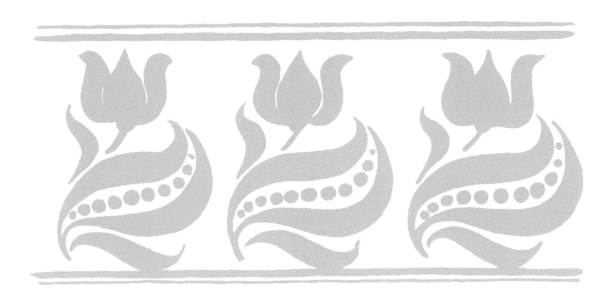

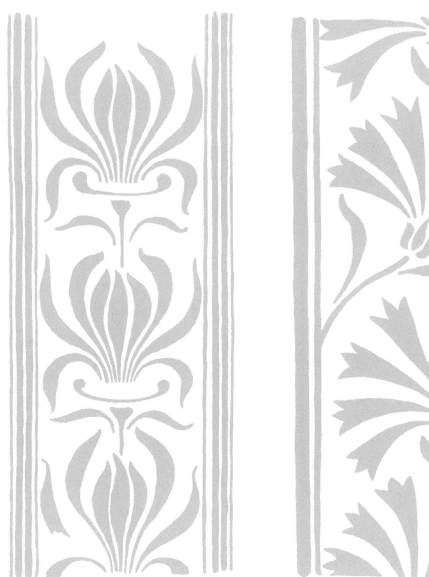
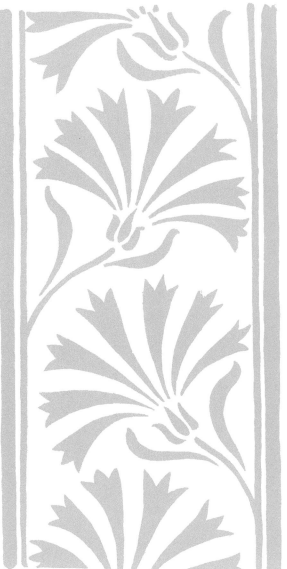

Plate XXII.—Series of designs drawn with the brush.

In the more difficult patterns, the position of important masses should be slightly indicated with pencil, after which the whole should be drawn direct with the brush, aiming rather at freedom than perfect symmetry.

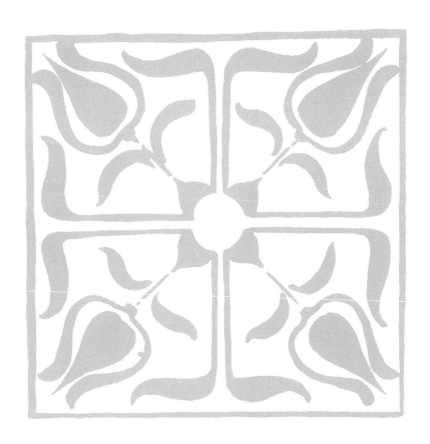

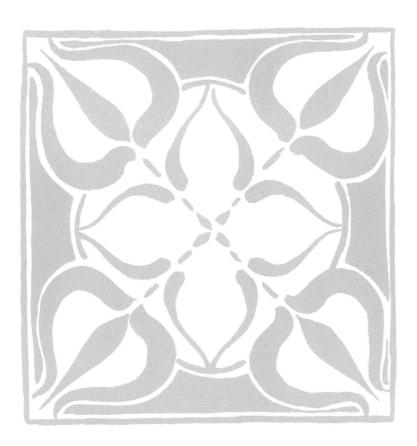

Plate XXIII.—Series of designs drawn with the brush.

In the more difficult patterns, the position of important masses should be slightly indicated with pencil, after which the whole should be drawn direct with the brush, aiming rather at freedom than perfect symmetry.

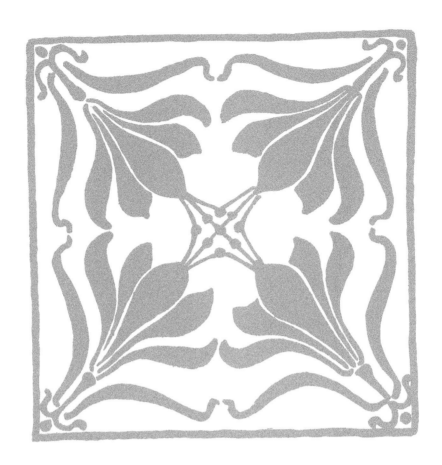

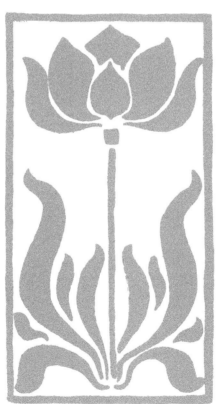

Plate XXIV.—Series of designs drawn with the brush.

In the more difficult patterns, the position of important masses should be slightly indicated with pencil, after which the whole should be drawn direct with the brush, aiming rather at freedom than perfect symmetry.

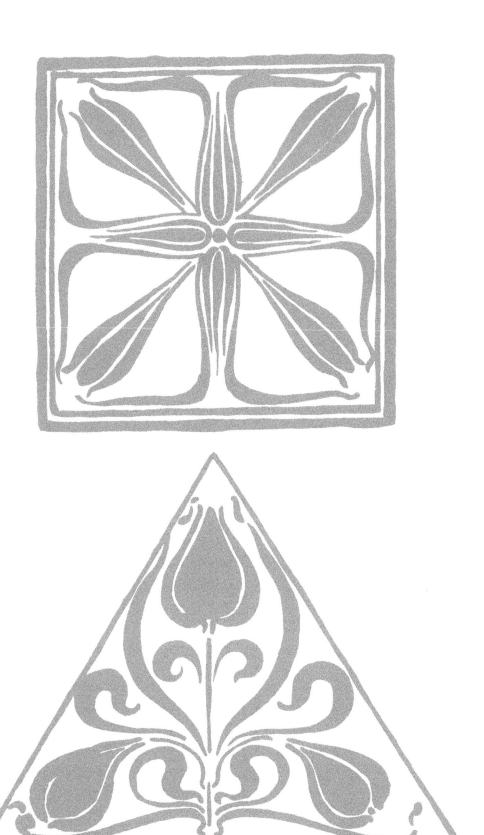

Plate XXV.—Series of designs drawn with the brush.

In the more difficult patterns, the position of important masses should be slightly indicated with pencil, after which the whole should be drawn direct with the brush, aiming rather at freedom than perfect symmetry.

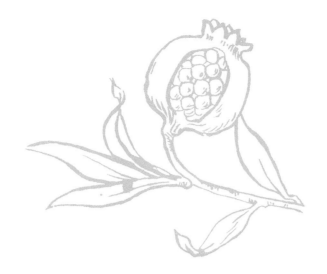

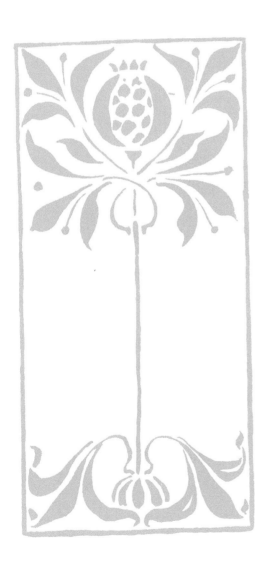

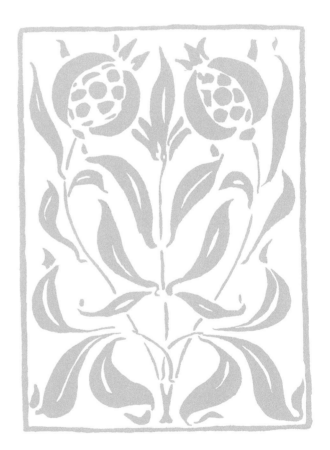

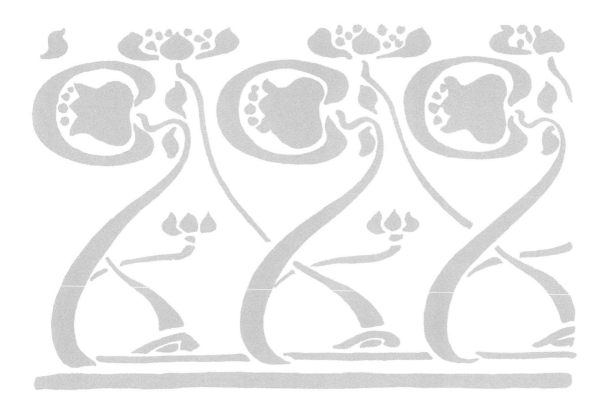

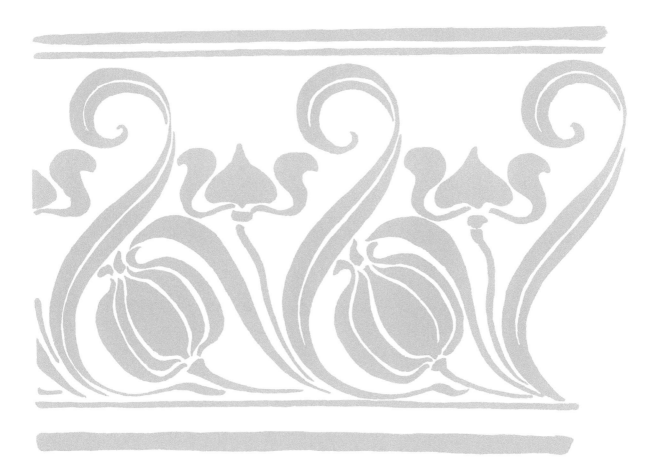

Plate XXVII.—Series of designs drawn with the brush.

In the more difficult patterns, the position of important masses should be slightly indicated with pencil, after which the whole should be drawn direct with the brush, aiming rather at freedom than perfect symmetry.

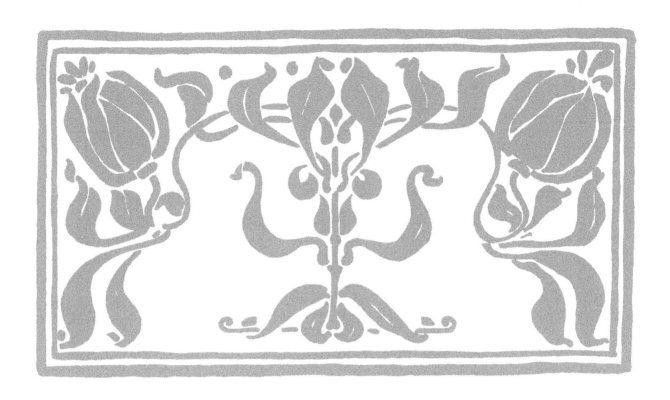

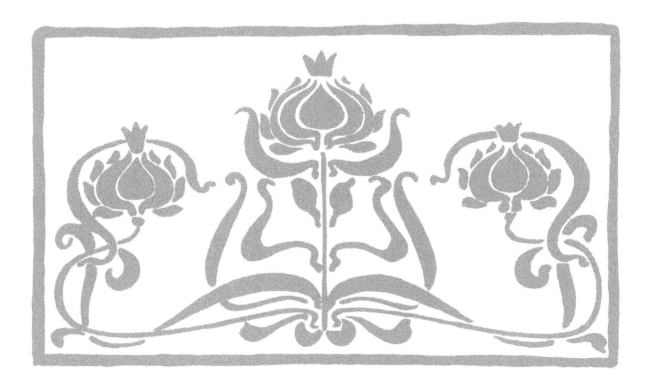

Plate XXVIII.—Series of designs drawn with the brush.

In the more difficult patterns, the position of important masses should be slightly indicated with pencil, after which the whole should be drawn direct with the brush, aiming rather at freedom than perfect symmetry.

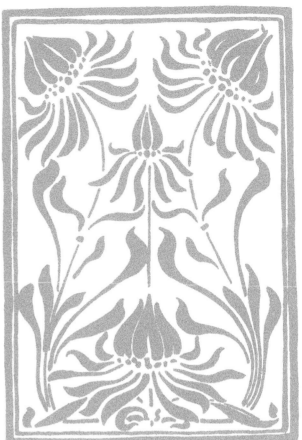

Plate XXIX.—Series of designs drawn with the brush.

In the more difficult patterns, the position of important masses should be slightly indicated with pencil, after which the whole should be drawn direct with the brush, aiming rather at freedom than perfect symmetry.

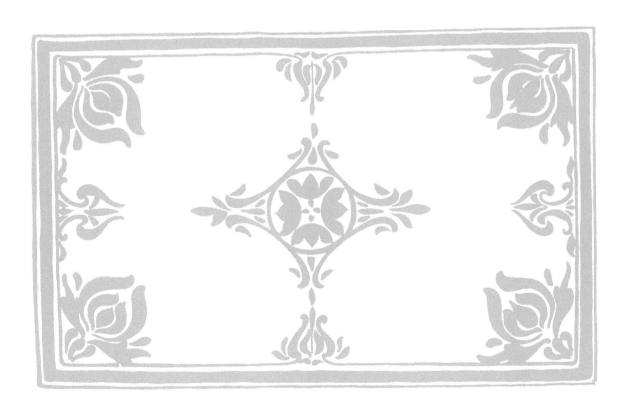

Plate XXX.—Series of designs drawn with the brush.

In the more difficult patterns, the position of important masses should be slightly indicated with pencil, after which the whole should be drawn direct with the brush, aiming rather at freedom than perfect symmetry.

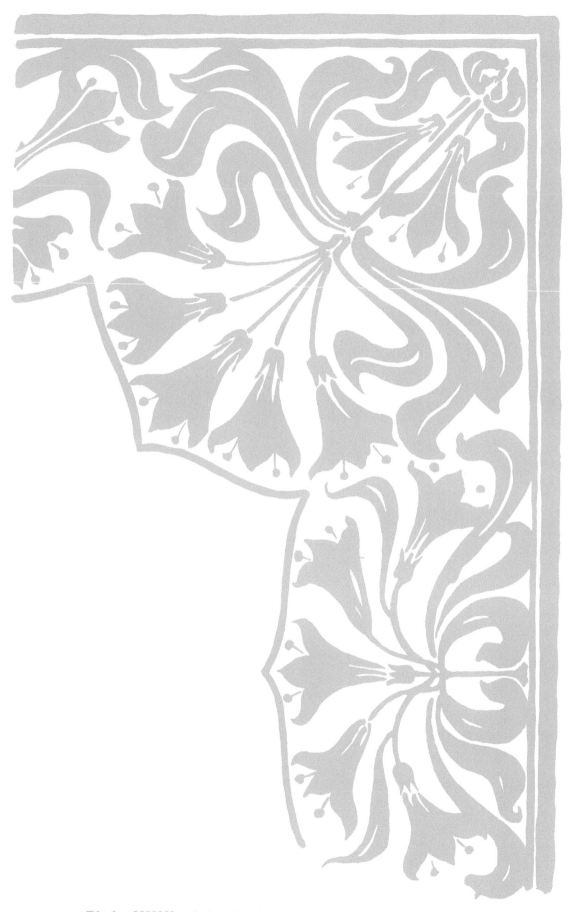

Plate XXXI.—Series of designs drawn with the brush.

In the more difficult patterns, the position of important masses should be slightly indicated with pencil, after which the whole should be drawn direct with the brush, aiming rather at freedom than perfect symmetry.

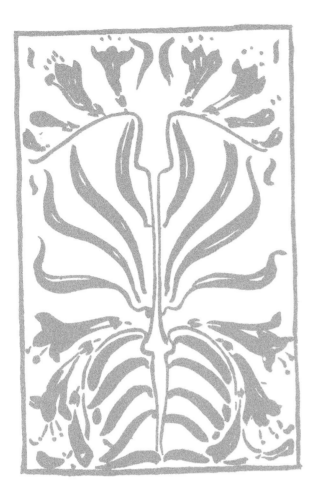
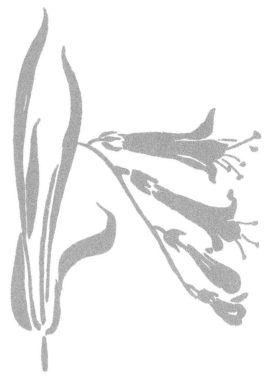

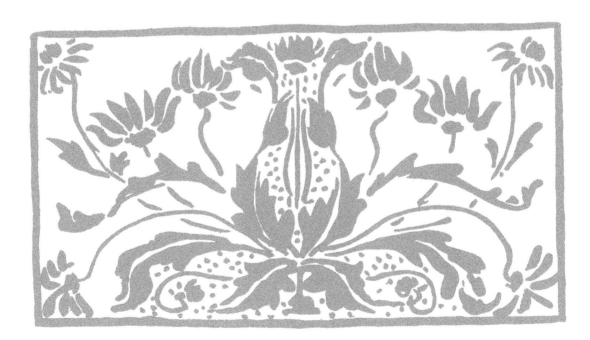

Plate XXXII.—Showing the use of the brush in directly suggesting the position of masses in design without using the pencil. The idea in this class of work is to express, by means of colour, the position and quantity of ornament in relation to the ground.

The student should have some set plant for motive, and make several such suggestions, afterwards using the ideas in working out the finished drawing. *(See Preface.)*

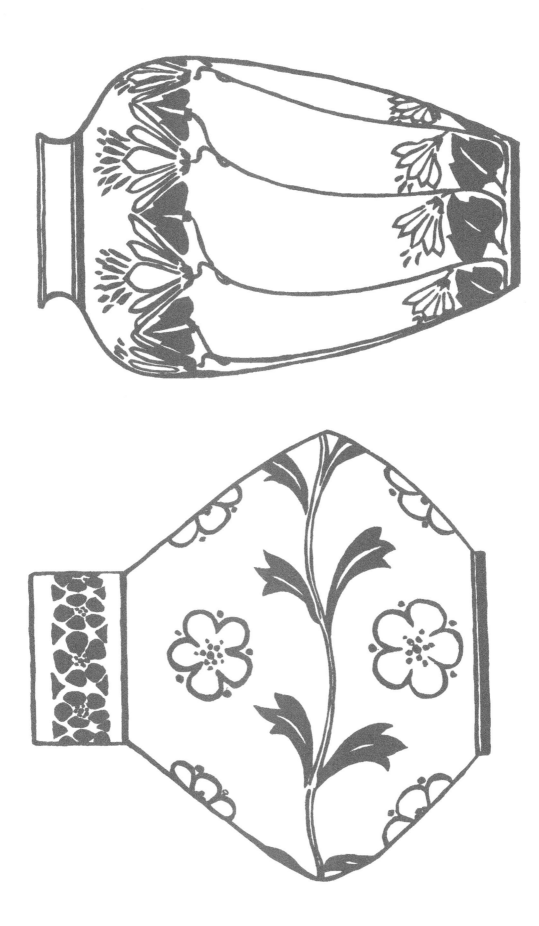

Plate XXXIII.—The decoration of vase forms by the repetition of a unit.
After indicating by means of the pencil the position of the important masses, the whole should be drawn with the brush.

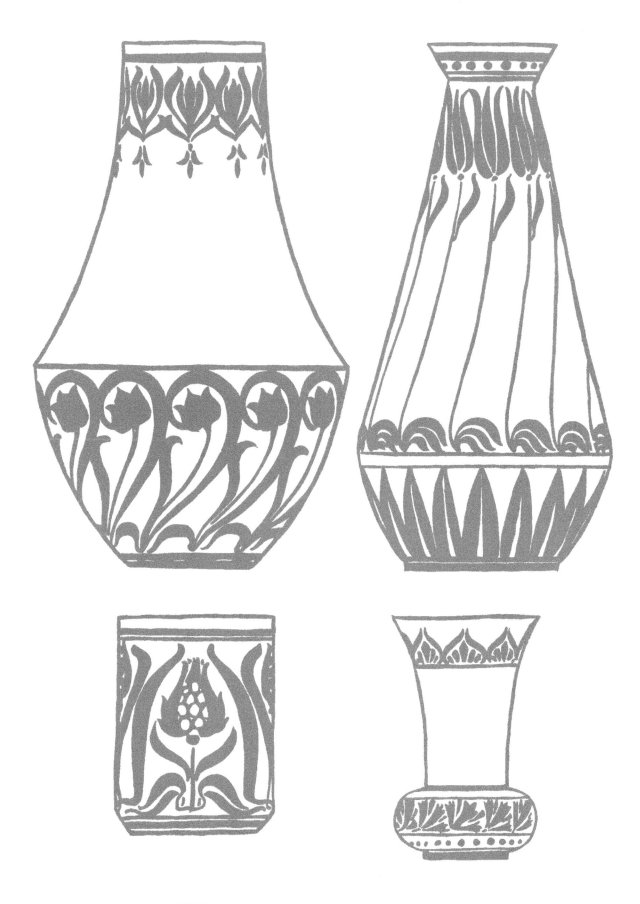

Plate XXXIV.—The decoration of vase forms by the repetition of a unit.

After indicating by means of the pencil the position of the important masses, the whole should be drawn with the brush.

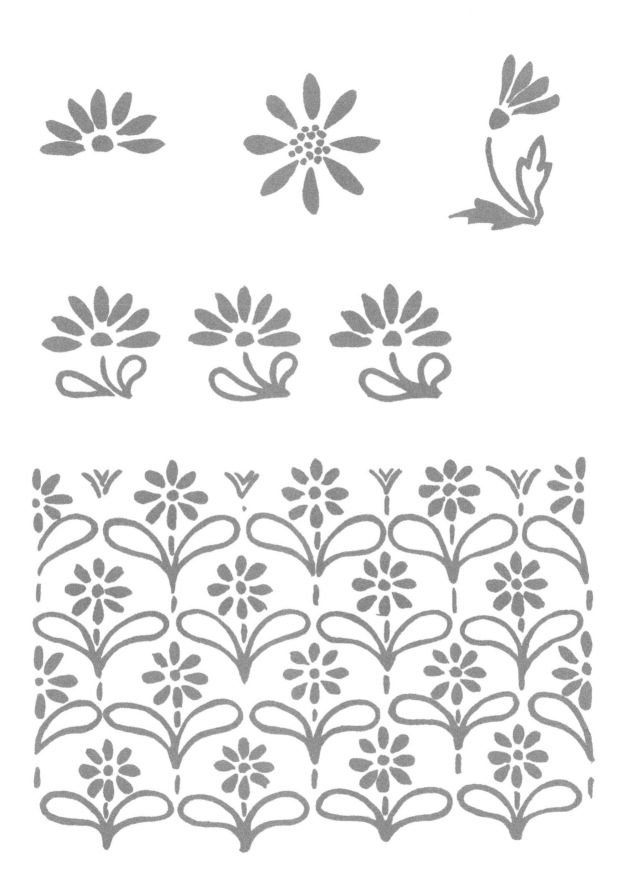

Plate XXXV.—Direct Freehand Drawing with the brush, typical floral and ornamental forms, afterwards re-combining them and designing direct with the brush.

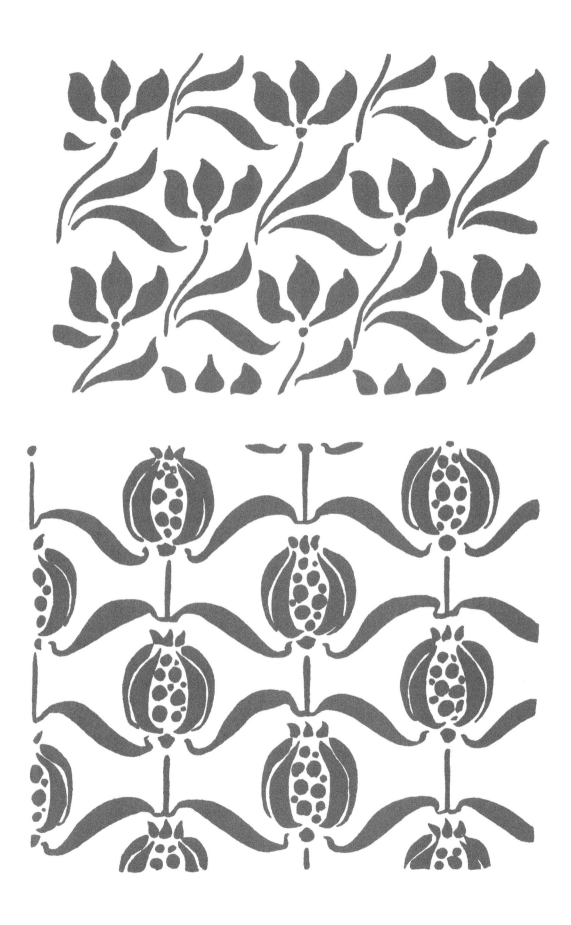

Plate XXXVI.—Direct Freehand Drawing with the brush, typical floral and ornamental forms, afterwards re-combining them and designing direct with the brush.

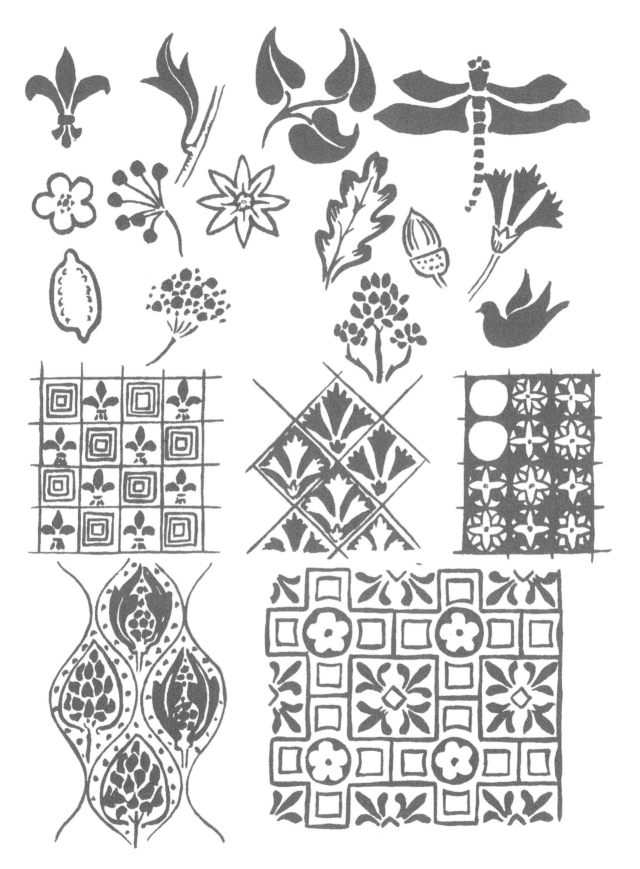

Plate XXXVII.—Designing upon given construction lines, forming repeating patterns suggested from simple given units.

Scholars should sketch out with the brush such simple units as illustrated, and then draw out construction lines based on the square, lozenge, and ogee, etc., and roughly suggest the position of units, and masses of dark on light ground alternating with light ornament on dark ground. From these quick impressions careful drawings can be afterwards worked out. *(See Preface.)*

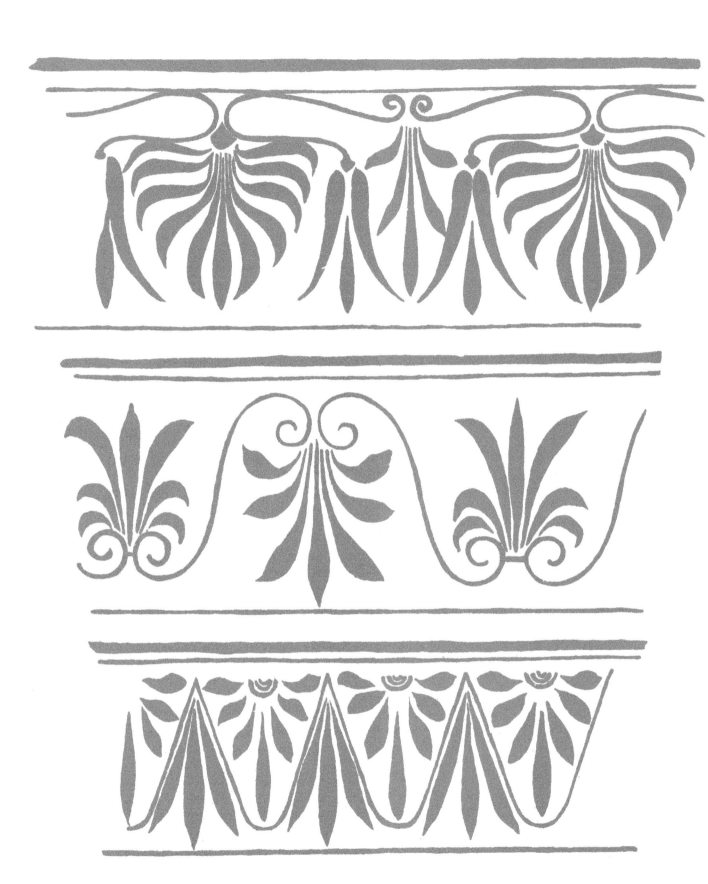

Plate XXXVIII.—Illustrations of Greek brush forms taken from Greek and Etruscan vases.

The Greek honeysuckle ornament is believed to have been suggested from the honeysuckle, as the Greeks frequently went to Nature for motives ; but it is more likely that this particular ornament generated from the direct use of the brush.

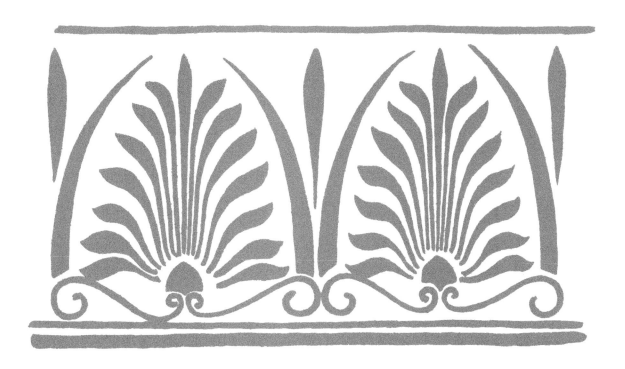

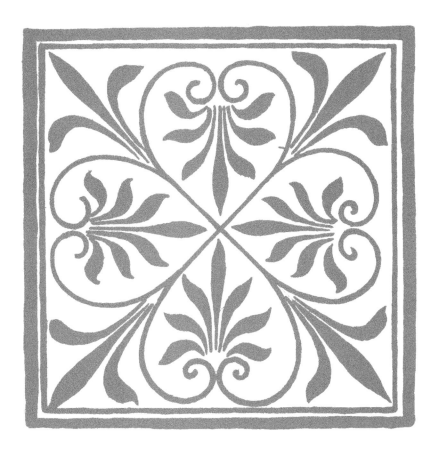

Plate XXXIX.—Illustrations of Greek brush forms taken from Greek and Etruscan vases.

The Greek honeysuckle ornament is believed to have been suggested from the honeysuckle, as the Greeks frequently went to Nature for motives; but it is more likely that this particular ornament generated from the direct use of the brush.

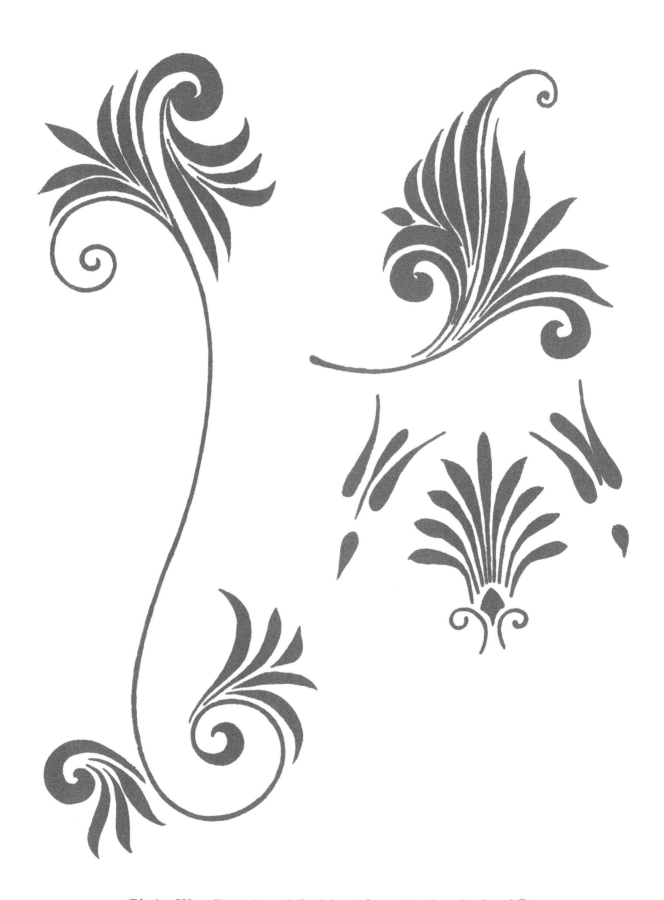

Plate XL.—Illustrations of Greek brush forms taken from Greek and Etruscan vases.

The Greek honeysuckle ornament is believed to have been suggested from the honeysuckle, as the Greeks frequently went to Nature for motives; but it is more likely that this particular ornament generated from the direct use of the brush.

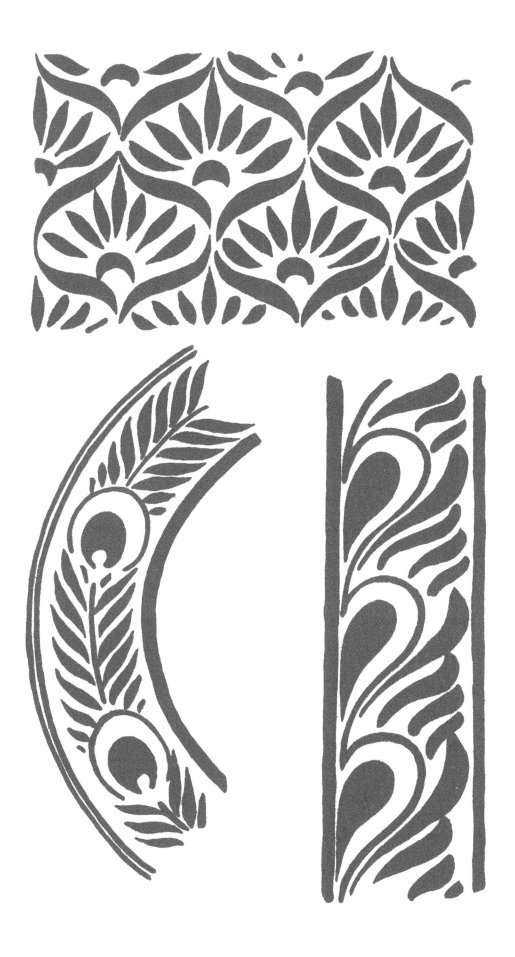

Plate XLI.—Examples of ornament taken from Italian majolica, Hispano moresque, and Persian pottery, showing specimens of direct brush drawing.

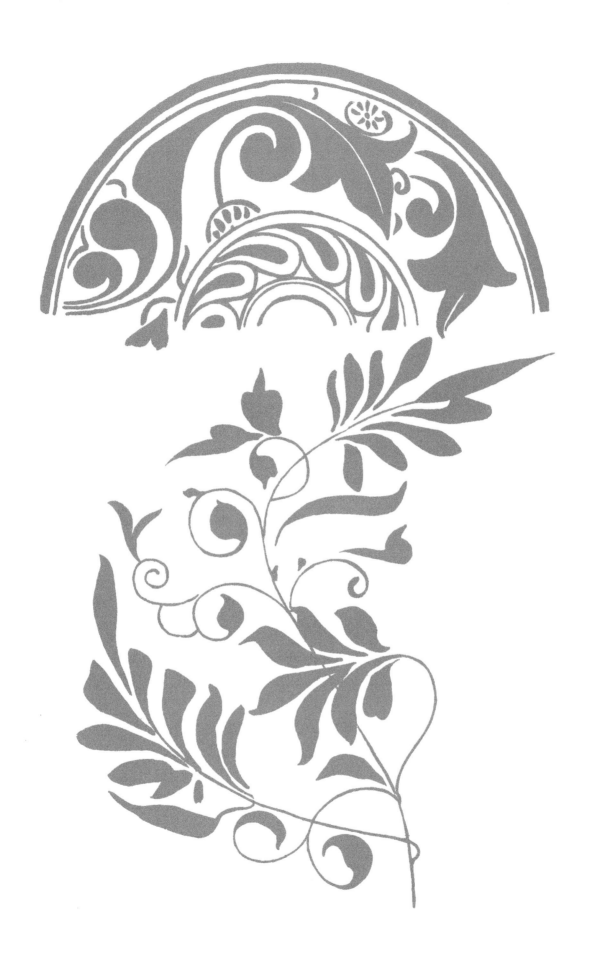

Plate XLII.—Examples of ornament taken from Italian majolica, Hispano moresque, and Persian pottery, showing specimens of direct brush drawing.

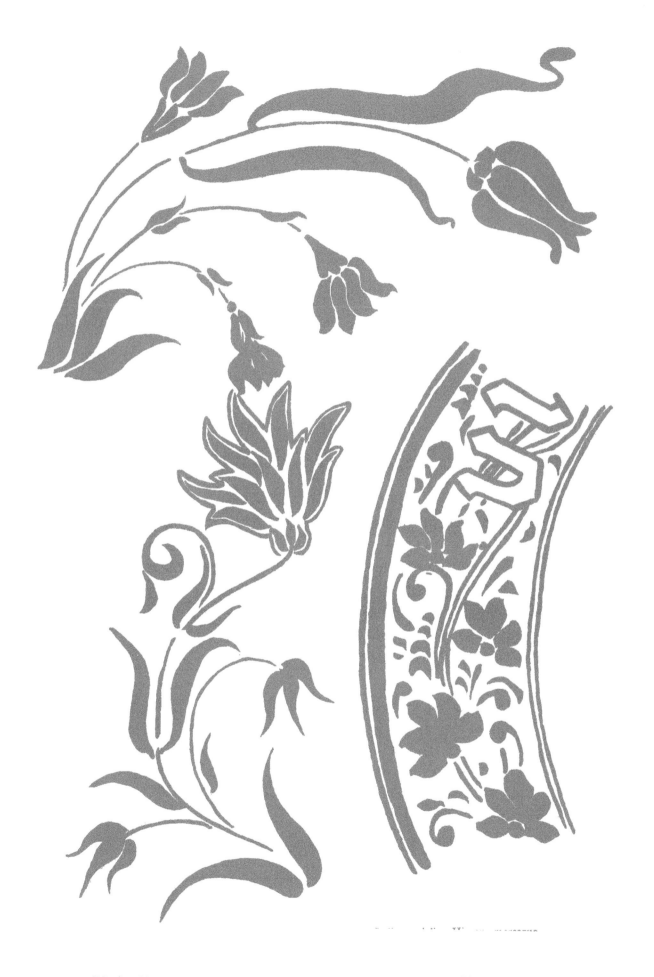

Plate XLIII.—Examples of ornament taken from Italian majolica, Hispano moresque, and Persian pottery, showing specimens of direct brush drawing.

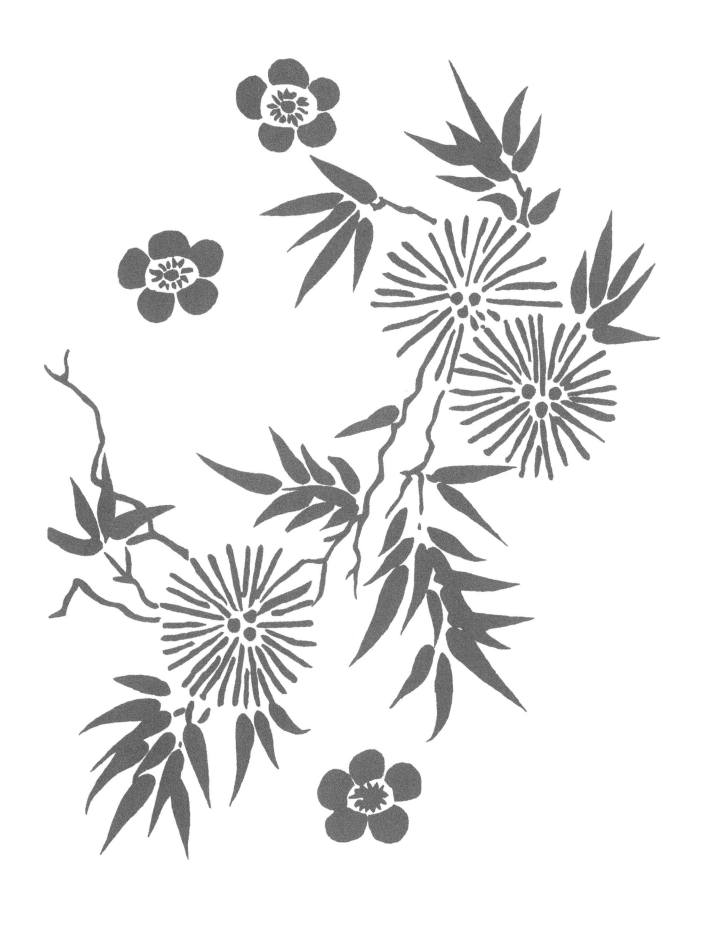

Plate XLIV.—Taken from a Japanese book cover, "powdered" pattern, showing the actual brush forms.

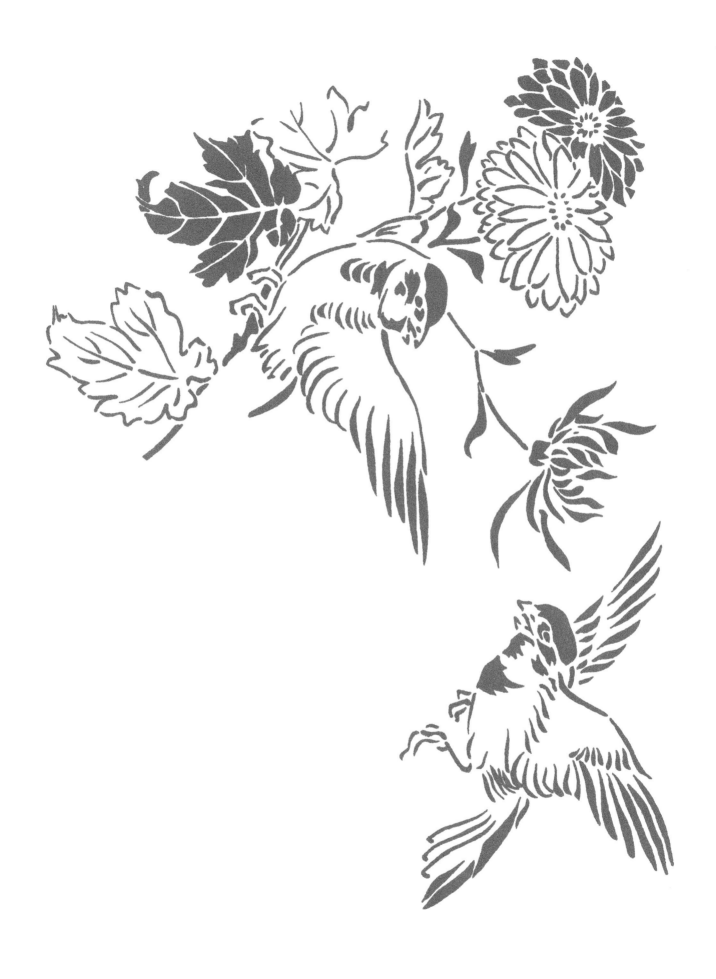

Plate XLV.—Taken from a Japanese stencil plate.

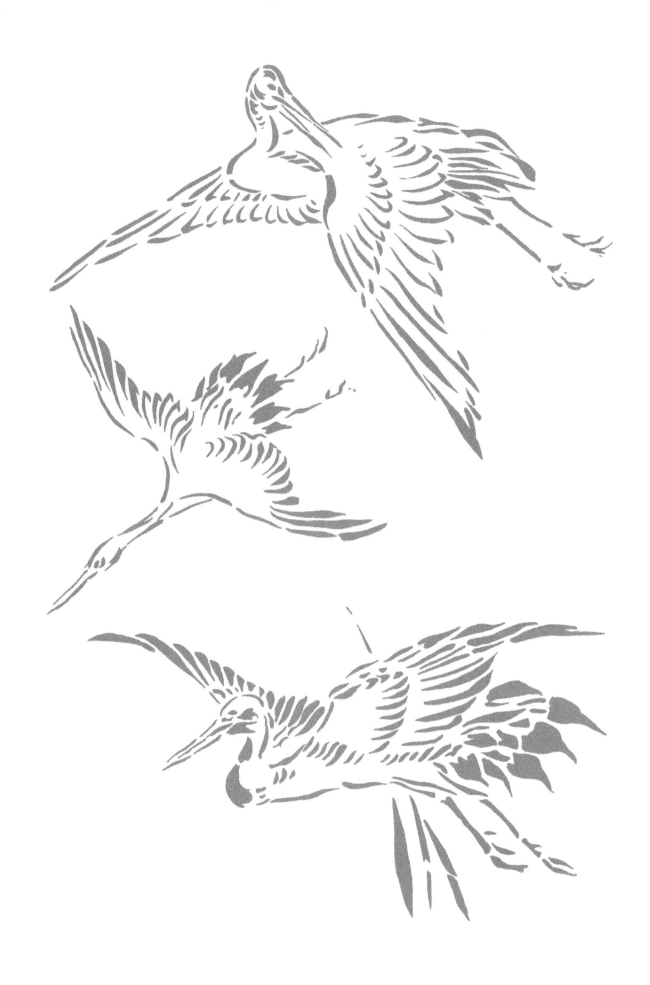

Plate XLVI.—Taken from a Japanese stencil plate.

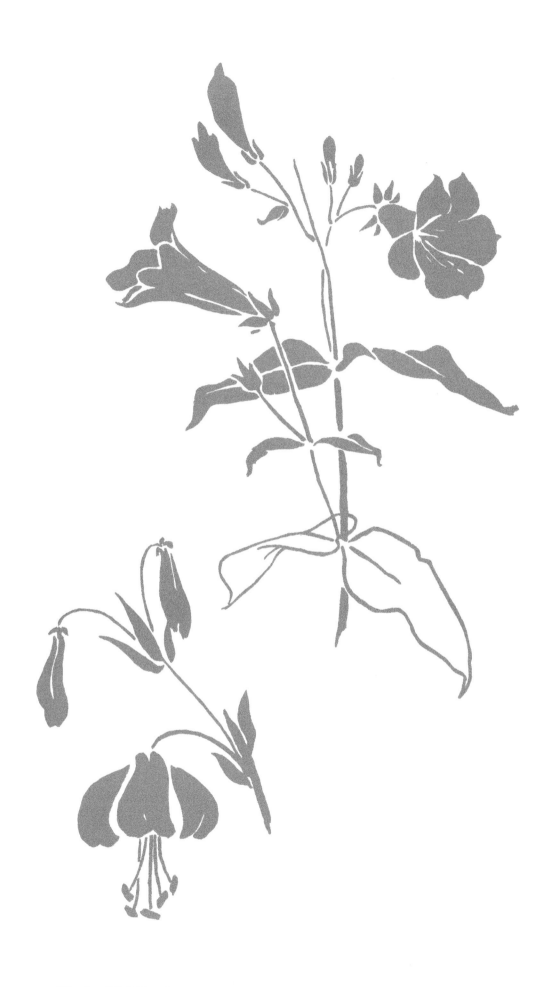

Plate XLVII.—Examples of direct sketching from Nature with the brush.

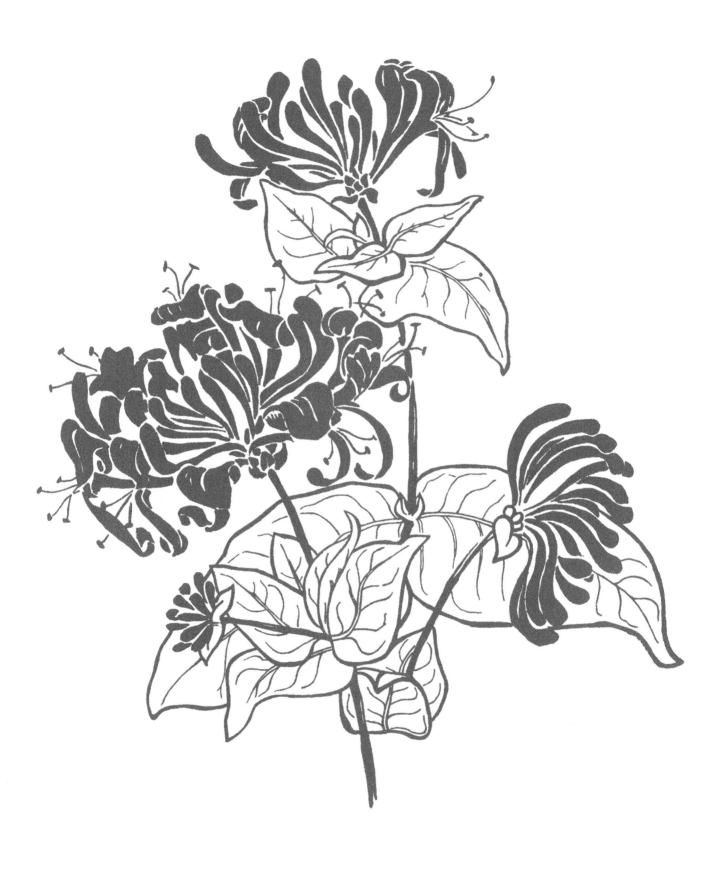

Plate XLVIII.—Examples of direct sketching from Nature with the brush.

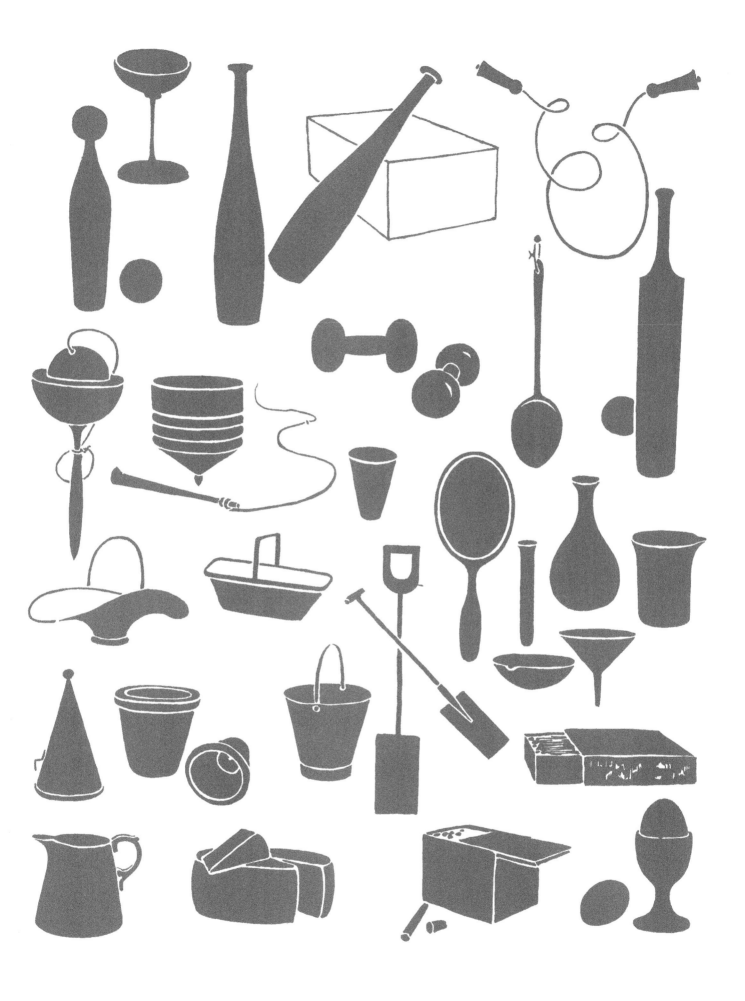

Plate XLIX.—Mass drawing of common objects direct with the brush.

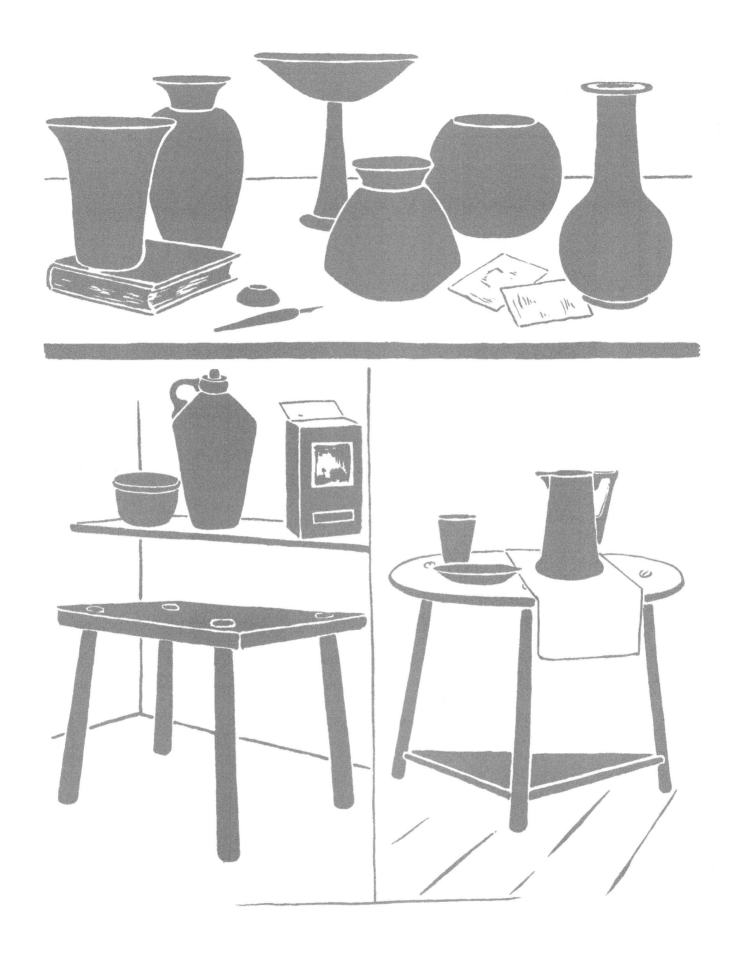

Plate L.—Mass drawing of groups of common objects.

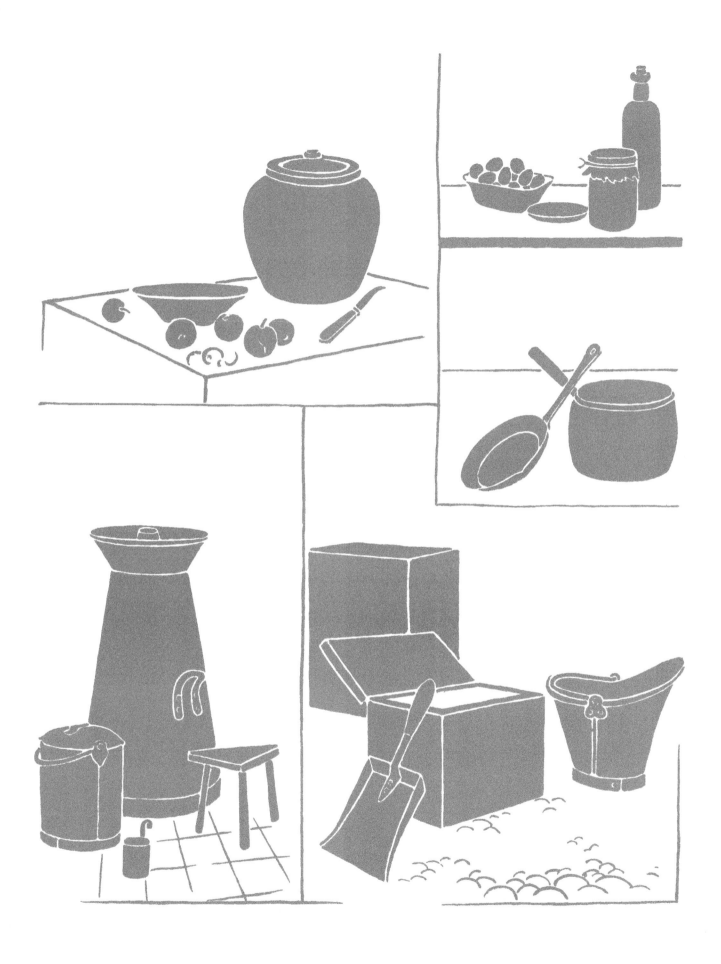

Plate LI.—Mass drawing of groups of common objects.

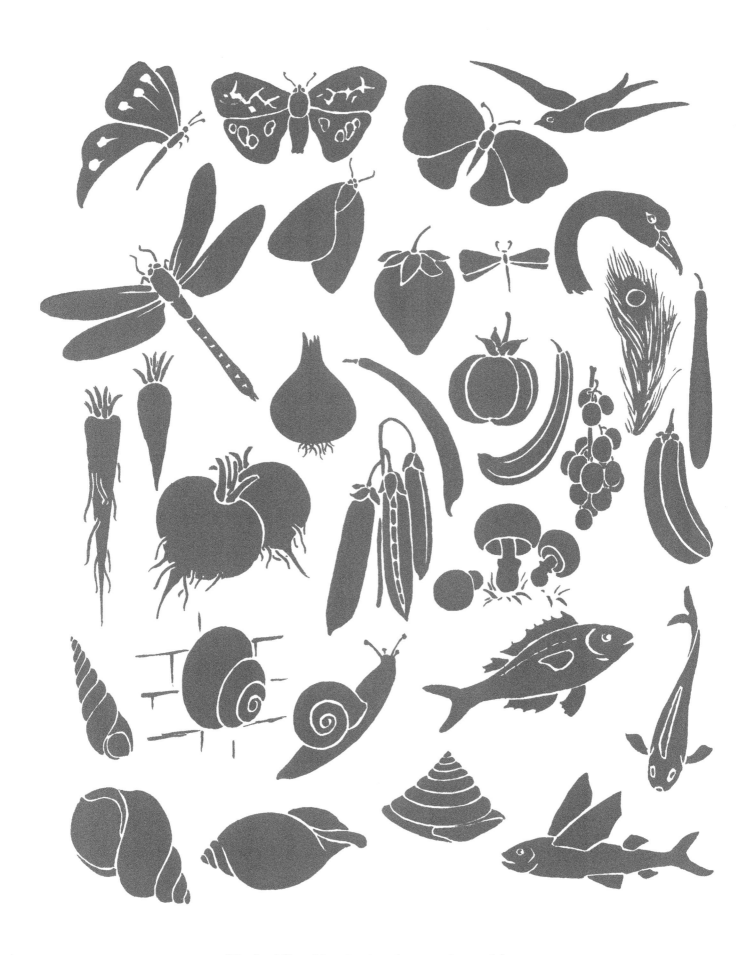

Plate LII. —Mass drawing of groups of natural forms.